The Earlier Work of Titian

The Earlier Work of Titian

Claude Phillips

1897

THE EARLIER WORK OF TITIAN

Published in the United States by IndyPublish.com
Boston, Massachusetts

Published in July 2007

ISBN 1-4353-2348-3 (paperback)

LIST OF ILLUSTRATIONS

PLATES

Flora Uffizi Gallery, Florence

Sacred and Profane Love Borghese Gallery, Rome

Virgin and Child, with Saints Louvre

Le Jeune Homme au Gant Louvre

ILLUSTRATIONS PRINTED IN COLOUR

Design for a Holy Family Chatsworth

Sketch for the Madonna di Casa Pesaro Albertina

ILLUSTRATIONS IN THE TEXT

The Man of Sorrows In the Scuola di S Rocco, Venice

Virgin and Child, known as "La Zingarella" Imperial Gallery, Vienna

The Baptism of Christ Gallery of the Capitol, Rome

The Three Ages Bridgewater Gallery

Herodias with the Head of John the Baptist Doria Gallery, Rome

Vanitas Alte Pinakothek, Munich

St Anthony of Padua causing a new-born Infant to speak Fresco in the Scuola del Santo, Padua

"Noli me tangere" National Gallery

St Mark enthroned, with four Saints S Maria della Salute, Venice

The Madonna with the Cherries Imperial Gallery, Vienna

PAGE Madonna and Child, with St John and St Anthony Abbot Uffizi Gallery, Florence

St Eustace (or St Hubert) with the Miracle of the Stag British Museum

The "Cristo della Moneta" Dresden Gallery

Madonna and Child, with four Saints Dresden Gallery

A Concert Probably by Titian Pitti Palace, Florence

Portrait of a Man Alte Pinakothek, Munich

Alessandro de' Medici (so called) Hampton Court

The Worship of Venus Prado Gallery, Madrid

The Assunta Accademia delle Belle Arti, Venice

The Annunciation Cathedral at Treviso

Bacchus and Ariadne National Gallery

St Sebastian Wing of altar-piece in the Church of SS Nazzaro e Celso, Brescia

La Vierge au Lapin Louvre

St Christopher with the Infant Christ Fresco in the Doge's Palace, Venice

The Madonna di Casa Pesaro Church of S Maria dei Frari, Venice

Martyrdom of St Peter the Dominican

Tobias and the Angel S Marciliano, Venice

INTRODUCTION

There is no greater name in Italian art—therefore no greater in art—than that of Titian. If the Venetian master does not soar as high as Leonardo da Vinci or Michelangelo, those figures so vast, so mysterious, that clouds even now gather round their heads and half-veil them from our view; if he has not the divine suavity, the perfect balance, not less of spirit than of answering hand, that makes Raphael an appearance unique in art, since the palmiest days of Greece; he is wider in scope, more glowing with the life-blood of humanity, more the poet-painter of the world and the world's fairest creatures, than any one of these. Titian is neither the loftiest, the most penetrating, nor the most profoundly moved among the great exponents of sacred art, even of his time and country. Yet is it possible, remembering the Entombment of the Louvre, the Assunta, the Madonna di Casa Pesaro, the St. Peter Martyr, to say that he has, take him all in all, been surpassed in this the highest branch of his art? Certainly nowhere else have the pomp and splendour of the

painter's achievement at its apogee been so consistently allied to a dignity and simplicity hardly ever overstepping the bounds of nature. The sacred art of no other painter of the full sixteenth century—not even that of Raphael himself—has to an equal degree influenced other painters, and moulded the style of the world, in those great ceremonial altar-pieces in which sacred passion must perforce express itself with an exaggeration that is not necessarily a distortion of truth.

And then as a portraitist—we are dealing, be it remembered, with Italian art only—there must be conceded to him the first place, as a limner both of men and women, though each of us may reserve a corner in his secret heart for some other master. One will remember the disquieting power, the fascination in the true sense of the word, of Leonardo; the majesty, the penetration, the uncompromising realism on occasion, of Raphael; the happy mixture of the Giorgionesque, the Raphaelesque, and later on the Michelangelesque, in Sebastiano del Piombo. Another will yearn for the poetic glamour, gilding realistic truth, of Giorgione; for the intensely pathetic interpretation of Lorenzo Lotto, with its unique combination of the strongest subjective and objective elements, the one serving to poetise and accentuate the other. Yet another will cite the lofty melancholy, the aristocratic charm of the Brescian Moretto, or the marvellous power of the Bergamasque Moroni to present in their natural union, with no indiscretion of over-emphasis, the spiritual and physical elements which go to make up that mystery of mysteries, the human individuality. There is, however, no advocate of any of these great masters who, having vaunted the peculiar perfections in portraiture of his own favourite, will not end—with a sigh perhaps—by according the palm to Titian.

In landscape his pre-eminence is even more absolute and unquestioned. He had great precursors here, but no equal; and until Claude Lorrain long afterwards arose, there appeared no successor capable, like himself, of expressing the quintessence of Nature's most significant beauties without a too slavish adherence to any special set of natural facts. Giovanni Bellini from his earliest Mantegnesque or Paduan days had, unlike his great brother-in-law, unlike the true Squarcionesques, and the Ferrarese who more or less remotely came within the Squarcionesque influence, the true gift of the landscape-painter. Atmospheric conditions formed invariably an important element of his conceptions; and to see that this is so we need only remember the chilly solemnity of the landscape in the great Pieta of the Brera, the ominous sunset in our own Agony in the Garden of the National Gallery, the cheerful all-pervading glow of the beautiful little Sacred Conversation at the Uffizi, the mysterious illumination of the late Baptism of Christ in the Church of S. Corona at Vicenza. To attempt a discussion of the landscape of Giorgione would be to enter upon the most perilous, as well as the most fascinating of subjects—so various is it even in the few well-established examples of his art, so exquisite an instrument of expression always, so complete an exterioration of the complex moods of his personages. Yet even the landscape of Giorgione—judging it from such unassailable works of his riper time as the great altar-piece of Castelfranco, the so-called Stormy Landscape with the Gipsy and the Soldier[1] in the Giovanelli Palace at Venice, and the so-called Three Philosophers in the Imperial Gallery at Vienna—has in it still a slight flavour of the ripe archaic just merging into full perfection. It was reserved for Titian to give in his early time the fullest development to the Giorgionesque landscape, as in the Three Ages and the Sacred and Profane Love. Then all himself, and

with hardly a rival in art, he went on to unfold those radiantly beautiful prospects of earth and sky which enframe the figures in the Worship of Venus, the Bacchanal, and, above all, the Bacchus and Ariadne; to give back his impressions of Nature in those rich backgrounds of reposeful beauty which so enhance the finest of the Holy Families and Sacred Conversations. It was the ominous grandeur of the landscape in the St. Peter Martyr, even more than the dramatic intensity, the academic amplitude of the figures, that won for the picture its universal fame. The same intimate relation between the landscape and the figures may be said to exist in the late Jupiter and Antiope (Venere del Pardo) of the Louvre, with its marked return to Giorgionesque repose and Giorgionesque communion with Nature; in the late Rape of Europa, the bold sweep and the rainbow hues of the landscape in which recall the much earlier Bacchus and Ariadne. In the exquisite Shepherd and Nymph of the Imperial Gallery at Vienna—a masterpiece in monotone of quite the last period—the sensuousness of the early Giorgionesque time reappears, even more strongly emphasised; yet it is kept in balance, as in the early days, by the imaginative temperament of the poet, by that solemn atmosphere of mystery, above all, which belongs to the final years of Titian's old age.

Thus, though there cannot be claimed for Titian that universality in art and science which the lovers of Leonardo's painting must ever deplore, since it lured him into a thousand side-paths; for the vastness of scope of Michelangelo, or even the all-embracing curiosity of Albrecht Duerer; it must be seen that as a painter he covered more ground than any first-rate master of the sixteenth century. While in more than one branch of the painter's art he stood forth supreme and without a rival, in most others he remained second to none, alone in great pictorial dec-

orations of the monumental order yielding the palm to his younger rivals Tintoretto and Paolo Veronese, who showed themselves more practised and more successfully daring in this particular branch.

To find another instance of such supreme mastery of the brush, such parallel activity in all the chief branches of oil-painting, one must go to Antwerp, the great merchant city of the North as Venice was, or had been, the great merchant city of the South. Rubens, who might fairly be styled the Flemish Titian, and who indeed owed much to his Venetian predecessor, though far less than did his own pupil Van Dyck, was during the first forty years of the seventeenth century on the same pinnacle of supremacy that the Cadorine master had occupied for a much longer period during the Renaissance. He, too, was without a rival in the creation of those vast altar-pieces which made the fame of the churches that owned them; he, too, was the finest painter of landscape of his time, as an accessory to the human figure. Moreover, he was a portrait-painter who, in his greatest efforts—those sumptuous and almost truculent portraits d'apparat of princes, nobles, and splendid dames—knew no superior, though his contemporaries were Van Dyck, Frans Hals, Rembrandt, and Velazquez. Rubens folded his Mother Earth and his fellow-man in a more demonstrative, a seemingly closer embrace, drawing from the contact a more exuberant vigour, but taking with him from its very closeness some of the stain of earth. Titian, though he was at least as genuine a realist as his successor, and one less content, indeed, with the mere outsides of things, was penetrated with the spirit of beauty which was everywhere—in the mountain home of his birth as in the radiant home of his adoption, in himself as in his everyday surroundings. His art had ever, even in its most human and least

aspiring phases, the divine harmony, the suavity tempering natural truth and passion, that distinguishes Italian art of the great periods from the finest art that is not Italian.

The relation of the two masters—both of them in the first line of the world's painters—was much that of Venice to Antwerp. The apogee of each city in its different way represented the highest point that modern Europe had reached of physical well-being and splendour, of material as distinguished from mental culture. But then Venice was wrapped in the transfiguring atmosphere of the Lagunes, and could see, towering above the rich Venetian plains and the lower slopes of the Friulan mountains, the higher, the more aspiring peaks of the purer region. Reality, with all its warmth and all its truth, in Venetian art was still reality. But it was reality made at once truer, wider, and more suave by the method of presentment. Idealisation, in the narrower sense of the word, could add nothing to the loveliness of such a land, to the stateliness, the splendid sensuousness devoid of the grosser elements of offence, to the genuine naturalness of such a mode of life. Art itself could only add to it the right accent, the right emphasis, the larger scope in truth, the colouring and illumination best suited to give the fullest expression to the beauties of the land, to the force, character, and warm human charm of the people. This is what Titian, supreme among his contemporaries of the greatest Venetian time, did with an incomparable mastery to which, in the vast field which his productions cover, it would be vain to seek for a parallel.

Other Venetians may, in one or the other way, more irresistibly enlist our sympathies, or may shine out for the moment more brilliantly in some special branch of their art; yet, after all, we find ourselves invariably comparing them to Titian, not Titian

to them—taking him as the standard for the measurement of even his greatest contemporaries and successors. Giorgione was of a finer fibre, and more happily, it may be, combined all the subtlest qualities of the painter and the poet, in his creation of a phase of art the penetrating exquisiteness of which has never in the succeeding centuries lost its hold on the world. But then Titian, saturated with the Giorgionesque, and only less truly the poet-painter than his master and companion, carried the style to a higher pitch of material perfection than its inventor himself had been able to achieve. The gifted but unequal Pordenone, who showed himself so incapable of sustained rivalry with our master in Venice, had moments of a higher sublimity than Titian reached until he came to the extreme limits of old age. That this assertion is not a mere paradox, the great Madonna del Carmelo at the Venice Academy and the magnificent Trinity in the sacristy of the Cathedral of San Daniele near Udine may be taken to prove. Yet who would venture to compare him on equal terms to the painter of the Assunta, the Entombment and the Christ at Emmaus? Tintoretto, at his best, has lightning flashes of illumination, a Titanic vastness, an inexplicable power of perturbing the spirit and placing it in his own atmosphere, which may cause the imaginative not altogether unreasonably to put him forward as the greater figure in art. All the same, if it were necessary to make a definite choice between the two, who would not uphold the saner and greater art of Titian, even though it might leave us nearer to reality, though it might conceive the supreme tragedies, not less than the happy interludes, of the sacred drama, in the purely human spirit and with the pathos of earth? A not dissimilar comparison might be instituted between the portraits of Lorenzo Lotto and those of our master. No Venetian painter of the golden prime had that peculiar imaginativeness of Lotto, which caused him, while seeking to pene-

trate into the depths of the human individuality submitted to him, to infuse into it unconsciously much of his own tremulous sensitiveness and charm. In this way no portraits of the sixteenth century provide so fascinating a series of riddles. Yet in deciphering them it is very necessary to take into account the peculiar temperament of the painter himself, as well as the physical and mental characteristics of the sitter and the atmosphere of the time.[2]

Yet where is the critic bold enough to place even the finest of these exquisite productions on the same level as Le Jeune Homme au Gant and L'Homme en Noir of the Louvre, the Ippolito de' Medici, the Bella di Tiziano, the Aretino of the Pitti, the Charles V. at the Battle of Muehlberg and the full-length Philip II. of the Prado Museum at Madrid?

Finally, in the domain of pure colour some will deem that Titian has serious rivals in those Veronese developed into Venetians, the two elder Bonifazi and Paolo Veronese; that is, there will be found lovers of painting who prefer a brilliant mastery over contrasting colours in frank juxtaposition to a palette relatively restricted, used with an art more subtle, if less dazzling than theirs, and resulting in a deeper, graver richness, a more significant beauty, if in a less stimulating gaiety and variety of aspect. No less a critic than Morelli himself pronounced the elder Bonifazio Veronese to be the most brilliant colourist of the Venetian school; and the Dives and Lazarus of the Venice Academy, the Finding of Moses at the Brera are at hand to give solid support to such an assertion.

In some ways Paolo Veronese may, without exaggeration, be held to be the greatest virtuoso among colourists, the most mar-

vellous executant to be found in the whole range of Italian art. Starting from the cardinal principles in colour of the true Veronese, his precursors—painters such as Domenico and Francesco Morone, Liberale, Girolamo dai Libri, Cavazzola, Antonio Badile, and the rather later Brusasorci—Caliari dared combinations of colour the most trenchant in their brilliancy as well as the subtlest and most unfamiliar. Unlike his predecessors, however, he preserved the stimulating charm while abolishing the abruptness of sheer contrast. This he did mainly by balancing and tempering his dazzling hues with huge architectural masses of a vibrant grey and large depths of cool dark shadow—brown shot through with silver. No other Venetian master could have painted the Mystic Marriage of St. Catherine in the church of that name at Venice, the Allegory on the Victory of Lepanto in the Palazzo Ducale, or the vast Nozze di Cana of the Louvre. All the same, this virtuosity, while it is in one sense a step in advance even of Giorgione, Titian, Palma, and Paris Bordone—constituting as it does more particularly a further development of painting from the purely decorative standpoint—must appear just a little superficial, a little self-conscious, by the side of the nobler, graver, and more profound, if in some ways more limited methods of Titian. With him, as with Giorgione, and, indeed, with Tintoretto, colour was above all an instrument of expression. The main effort was to give a realisation, at once splendid and penetrating in its truth, of the subject presented; and colour in accordance with the true Venetian principle was used not only as the decorative vesture, but as the very body and soul of painting—as what it is, indeed, in Nature.

To put forward Paolo Veronese as merely the dazzling virtuoso would all the same be to show a singular ignorance of the true scope of his art. He can rise as high in dramatic passion and

pathos as the greatest of them all, when he is in the vein; but these are precisely the occasions on which he most resolutely subordinates his colour to his subject and makes the most poetic use of chiaroscuro; as in the great altar-piece The Martyrdom of St. Sebastian in the church of that name, the too little known St. Francis receiving the Stigmata on a ceiling compartment of the Academy of Arts at Vienna, and the wonderful Crucifixion which not many years ago was brought down from the sky-line of the Long Gallery in the Louvre, and placed, where it deserves to be, among the masterpieces. And yet in this last piece the colour is not only in a singular degree interpretative of the subject, but at the same time technically astonishing—with certain subtleties of unusual juxtaposition and modulation, delightful to the craftsman, which are hardly seen again until we come to the latter half of the present century. So that here we have the great Veneto-Veronese master escaping altogether from our theory, and showing himself at one and the same time profoundly moving, intensely significant, and admirably decorative in colour. Still what was with him the splendid exception was with Titian, and those who have been grouped with Titian, the guiding rule of art. Though our master remains, take him all in all, the greatest of Venetian colourists, he never condescends to vaunt all that he knows, or to select his subjects as a groundwork for bravura, even the most legitimate. He is the greatest painter of the sixteenth century, just because, being the greatest colourist of the higher order, and in legitimate mastery of the brush second to none, he makes the worthiest use of his unrivalled accomplishment, not merely to call down the applause due to supreme pictorial skill and the victory over self-set difficulties, but, above all, to give the fullest and most legitimate expression to the subjects which he presents, and through them to himself.

CHAPTER I

Cadore and Venice—Early Giorgionesque works up to the date of the residence in Padua—New interpretations of Giorgione's and Titian's pictures.

Tiziano Vecelli was born in or about the year 1477 at Pieve di Cadore, a district of the southern Tyrol then belonging to the Republic of Venice, and still within the Italian frontier. He was the son of Gregorio di Conte Vecelli by his wife Lucia, his father being descended from an ancient family of the name of Guecello (or Vecellio), established in the valley of Cadore. An ancestor, Ser Guecello di Tommasro da Pozzale, had been elected Podesta of Cadore as far back as 1321.[3] The name Tiziano would appear to have been a traditional one in the family. Among others we find a contemporary Tiziano Vecelli, who is a lawyer of note concerned in the administration of Cadore, keeping up a kind of obsequious friendship with his famous cousin

at Venice. The Tizianello who, in 1622, dedicated to the Countess of Arundel an anonymous Life of Titian known as Tizianello's Anonimo, and died at Venice in 1650, was Titian's cousin thrice removed.

Gregorio Vecelli was a valiant soldier, distinguished for his bravery in the field and his wisdom in the council of Cadore, but not, it may be assumed, possessed of wealth or, in a poor mountain district like Cadore, endowed with the means of obtaining it. The other offspring of the marriage with Lucia were Francesco,—supposed, though without substantial proof, to have been older than his brother,—Caterina, and Orsa. At the age of nine, according to Dolce in the Dialogo della Pittura, or of ten, according to Tizianello's Anonimo, Titian was taken from Cadore to Venice, there to enter upon the serious study of painting. Whether he had previously received some slight tuition in the rudiments of the art, or had only shown a natural inclination to become a painter, cannot be ascertained with any precision; nor is the point, indeed, one of any real importance. What is much more vital in our study of the master's life-work is to ascertain how far the scenery of his native Cadore left a permanent impress on his landscape art, and in what way his descent from a family of mountaineers and soldiers, hardy, yet of a certain birth and breeding, contributed to shape his individuality in its development to maturity. It has been almost universally assumed that Titian throughout his career made use of the mountain scenery of Cadore in the backgrounds to his pictures; and yet, if we except the great Battle of Cadore itself (now known only in Fontana's print, in a reduced version of part of the composition to be found at the Uffizi, and in a drawing of Rubens at the Albertina), this is only true in a modified sense. Undoubtedly, both in the backgrounds to altar-pieces, Holy

Families, and Sacred Conversations, and in the landscape drawings of the type so freely copied and adapted by Domenico Campagnola, we find the jagged, naked peaks of the Dolomites aspiring to the heavens. In the majority of instances, however, the middle distance and foreground to these is not the scenery of the higher Alps, with its abrupt contrasts, its monotonous vesture of fir or pine forests clothing the mountain sides, and its relatively harsh and cold colouring, but the richer vegetation of the Friulan mountains in their lower slopes, or of the beautiful hills bordering upon the overflowing richness of the Venetian plain. Here the painter found greater variety, greater softness in the play of light, and a richness more suitable to the character of Venetian art. All these tracts of country, as well as the more grandiose scenery of his native Cadore itself, he had the amplest opportunities for studying in the course of his many journeyings from Venice to Pieve and back, as well as in his shorter expeditions on the Venetian mainland. How far Titian's Alpine origin, and his early bringing-up among needy mountaineers, may be taken to account for his excessive eagerness to reap all the material advantages of his artistic pre-eminence, for his unresting energy when any post was to be obtained or any payment to be got in, must be a matter for individual appreciation. Josiah Gilbert—quoted by Crowe and Cavalcaselle[4]—pertinently asks, "Might this mountain man have been something of a 'canny Scot' or a shrewd Swiss?" In the getting, Titian was certainly all this, but in the spending he was large and liberal, inclined to splendour and voluptuousness, even more in the second than in the first half of his career. Vasari relates that Titian was lodged at Venice with his uncle, an "honourable citizen," who, seeing his great inclination for painting, placed him under Giovanni Bellini, in whose style he soon became a proficient. Dolce, apparently better instructed, gives, in his Dialogo

della Pittura, Zuccato, best known as a mosaic worker, as his first master; next makes him pass into the studio of Gentile Bellini, and thence into that of the caposcuola Giovanni Bellini; to take, however, the last and by far the most important step of his early career when he becomes the pupil and partner, or assistant, of Giorgione. Morelli[5] would prefer to leave Giovanni Bellini altogether out of Titian's artistic descent. However this may be, certain traces of Gentile's influence may be observed in the art of the Cadorine painter, especially in the earlier portraiture, but indeed in the methods of technical execution generally. On the other hand, no extant work of his beginnings suggests the view that he was one of the inner circle of Gian Bellino's pupils—one of the discipuli, as some of these were fond of describing themselves. No young artist painting in Venice in the last years of the fifteenth century could, however, entirely withdraw himself from the influence of the veteran master, whether he actually belonged to his following or not. Gian Bellino exercised upon the contemporary art of Venice and the Veneto an influence not less strong of its kind than that which radiated from Leonardo over Milan and the adjacent regions during his Milanese period. The latter not only stamped his art on the works of his own special school, but fascinated in the long run the painters of the specifically Milanese group which sprang from Foppa and Borgognone—such men as Ambrogio de' Predis, Bernardino de' Conti, and, indeed, the somewhat later Bernardino Luini himself. To the fashion for the Bellinesque conceptions of a certain class, even Alvise Vivarini, the vigorous head of the opposite school in its latest Quattrocento development, bowed when he painted the Madonnas of the Redentore and S. Giovanni in Bragora at Venice, and that similar one now in the Vienna Gallery. Lorenzo Lotto, whose artistic connection with Alvise Mr. Bernard Berenson was the first to trace, is to a

marked extent under the paramount influence of Giovanni Bellini in such works as the altar-piece of S. Cristina near Treviso, the Madonna and Child with Saints in the Ellesmere collection, and the Madonna and Child with St. Peter Martyr in the Naples Gallery, while in the Marriage of St. Catherine at Munich, though it belongs to the early time, he is, both as regards exaggerations of movement and delightful peculiarities of colour, essentially himself. Marco Basaiti, who, up to the date of Alvise's death, was intimately connected with him, and, so far as he could, faithfully reproduced the characteristics of his incisive style, in his later years was transformed into something very like a satellite of Giovanni Bellini. Cima, who in his technical processes belongs rather to the Vivarini than to the Bellini group, is to a great extent overshadowed, though never, as some would have it, absorbed to the point of absolute imitation, by his greater contemporary.

What may legitimately excite surprise in the beginnings both of Giorgione and Titian, so far as they are at present ascertained, is not so much that in their earliest productions they to a certain extent lean on Giovanni Bellini, as that they are so soon themselves. Neither of them is in any extant work seen to stand in the same absolutely dependent relation to the veteran Quattrocentist which Raphael for a time held towards Perugino, which Sebastiano Luciani in his earliest manhood held towards Giorgione. This holds good to a certain extent also of Lorenzo Lotto, who, in the earliest known examples—the so-called Danae of Sir Martin Conway's collection, and the St. Jerome of the Louvre—is already emphatically Lotto, though, as his art passes through successive developments, he will still show himself open to more or less enduring influences from the one side and the other. Sebastiano del Piombo, on the other hand, great

master as he must undoubtedly be accounted in every successive phase, is never throughout his career out of leading-strings. First, as a boy, he paints the puzzling Pieta in the Layard Collection at Venice, which, notwithstanding the authentic inscription, "Bastian Luciani fuit descipulus Johannes Bellinus (sic)," is so astonishingly like a Cima that, without this piece of documentary evidence, it would even now pass as such. Next, he becomes the most accomplished exponent of the Giorgionesque manner, save perhaps Titian himself. Then, migrating to Rome, he produces, in a quasi-Raphaelesque style still strongly tinged with the Giorgionesque, that series of superb portraits which, under the name of Sanzio, have acquired a world-wide fame. Finally, surrendering himself body and soul to Michelangelo, and only unconsciously, from the force of early training and association, allowing his Venetian origin to reveal itself, he remains enslaved by the tremendous genius of the Florentine to the very end of his career.

Giorgione and Titian were as nearly as possible of the same age, being both of them born in or about 1477. Lorenzo Lotto's birth is to be placed about the year 1476—or, as others would have it, 1480. Palma saw the light about 1480, Pordenone in 1483, Sebastiano Luciani in 1485. So that most of the great protagonists of Venetian art during the earlier half of the Cinquecento were born within the short period of eight years—between 1477 and 1485.

In Crowe and Cavalcaselle's Life and Times of Titian a revolutionary theory, foreshadowed in their Painting in North Italy, was for the first time deliberately put forward and elaborately sustained. They sought to convince the student, as they had convinced themselves, that Palma, issuing from Gian Bellino

and Giorgione, strongly influenced and shaped the art of his contemporary Titian, instead of having been influenced by him, as the relative position and age of the two artists would have induced the student to believe. Crowe and Cavalcaselle's theory rested in the main, though not so entirely as Giovanni Morelli appears to have held, on the signature and the early date (1500) to be found on a Santa Conversazione, once in the collection of M. Reiset, and now at Chantilly in that of the late Due d'Aumale. This date now proves with the artist's signature to be a forgery, and the picture in question, which, with strong traces still of the Bellinesque mode of conception and the Bellinesque style, shows a larger and more modern technique, can no longer be cited as proving the priority of Palma in the development of the full Renaissance types and the full Renaissance methods of execution. There can be small doubt that this particular theory of the indefatigable critics, to whom the history of Italian art owes so much, will little by little be allowed to die a natural death, if it be not, indeed, already defunct. More and more will the view so forcibly stated by Giovanni Morelli recommend itself, that Palma in many of those elements of his art most distinctively Palmesque leans upon the master of Cadore. The Bergamasque painter was not indeed a personality in art sufficiently strong and individual to dominate a Titian, or to leave upon his style and methods profound and enduring traces. As such, Crowe and Cavalcaselle themselves hesitate to put him forward, though they cling with great persistency to their pet theory of his influence. This exquisite artist, though by no means inventive genius, did, on the other hand, permanently shape the style of Cariani and the two elder Bonifazi; imparting, it may be, also some of his voluptuous charm in the rendering of female loveliness to Paris Bordone, though the latter must, in the main, be looked upon as the artistic offspring of Titian.

It is by no means certain, all the same, that this question of influence imparted and submitted to can with advantage be argued with such absoluteness of statement as has been the rule up to the present time, both on the one side and the other. It should be remembered that we are dealing with three young painters of about the same age, working in the same art-centre, perhaps, even, for a time in the same studio—issuing, at any rate, all three from the flank of Giovanni Bellini. In a situation like this, it is not only the preponderance of age—two or three years at the most, one way or the other—that is to be taken into account, but the preponderance of genius and the magic gift of influence. It is easy to understand how the complete renewal, brought about by Giorgione on the basis of Bellini's teaching and example, operated to revolutionise the art of his own generation. He threw open to art the gates of life in its mysterious complexity, in its fulness of sensuous yearning commingled with spiritual aspiration. Irresistible was the fascination exercised both by his art and his personality over his youthful contemporaries; more and more did the circle of his influence widen, until it might almost be said that the veteran Gian Bellino himself was brought within it. With Barbarelli, at any rate, there could be no question of light received back from painters of his own generation in exchange for that diffused around him; but with Titian and Palma the case was different. The germs of the Giorgionesque fell here in each case upon a fruitful soil, and in each case produced a vigorous plant of the same family, yet with all its Giorgionesque colour of a quite distinctive loveliness. Titian, we shall see, carried the style to its highest point of material development, and made of it in many ways a new thing. Palma, with all his love of beauty in colour and form, in nature as in man, had a less finely attuned artistic temperament than

Giorgione, Titian, or Lotto. Morelli has called attention to that element of downright energy in his mountain nature which in a way counteracts the marked sensuousness of his art, save when he interprets the charms of the full-blown Venetian woman. The great Milanese critic attributes this to the Bergamasque origin of the artist, showing itself beneath Venetian training. Is it not possible that a little of this frank unquestioning sensuousness on the one hand, of this terre a terre energy on the other, may have been reflected in the early work of Titian, though it be conceded that he influenced far more than he was influenced?[6] There is undoubtedly in his personal development of the Giorgionesque a superadded element of something much nearer to the everyday world than is to be found in the work of his prototype, and this not easily definable element is peculiar also to Palma's art, in which, indeed, it endures to the end. Thus there is a singular resemblance between the type of his fairly fashioned Eve in the important Adam and Eve of his earlier time in the Brunswick Gallery—once, like so many other things, attributed to Giorgione—and the preferred type of youthful female loveliness as it is to be found in Titian's Three Ages at Bridgewater House, in his so-called Sacred and Profane Love (Medea and Venus) of the Borghese Gallery, in such sacred pieces as the Madonna and Child with SS. Ulfo and Brigida at the Prado Gallery of Madrid, and the large Madonna and Child with four Saints at Dresden. In both instances we have the Giorgionesque conception stripped of a little of its poetic glamour, but retaining unabashed its splendid sensuousness, which is thus made the more markedly to stand out. We notice, too, in Titian's works belonging to this particular group another characteristic which may be styled Palmesque, if only because Palma indulged in it in a great number of his Sacred Conversations and similar pieces. This is the contrasting of the rich brown skin, the

muscular form, of some male saint, or it may be some shepherd of the uplands, with the dazzling fairness, set off with hair of pale or ruddy gold, of a female saint, or a fair Venetian doing duty as a shepherdess or a heroine of antiquity. Are we to look upon such distinguishing characteristics as these—and others that could easily be singled out—as wholly and solely Titianesque of the early time? If so, we ought to assume that what is most distinctively Palmesque in the art of Palma came from the painter of Cadore, who in this case should be taken to have transmitted to his brother in art the Giorgionesque in the less subtle shape into which he had already transmuted it. But should not such an assumption as this, well founded as it may appear in the main, be made with all the allowances which the situation demands?

That, when a group of young and enthusiastic artists, eager to overturn barriers, are found painting more or less together, it is not so easy to unravel the tangle of influences and draw hard-and-fast lines everywhere, one or two modern examples much nearer to our own time may roughly serve to illustrate. Take, for instance, the friendship that developed itself between the youthful Bonington and the youthful Delacroix while they copied together in the galleries of the Louvre: the one communicating to the other something of the stimulating quality, the frankness, and variety of colour which at that moment distinguished the English from the French school; the other contributing to shape, with the fire of his romantic temperament, the art of the young Englishman who was some three years his junior. And with the famous trio of the P.R.B.—Millais, Rossetti, and Mr. Holman Hunt—who is to state ex cathedra where influence was received, where transmitted; or whether the first may fairly be held to have been, during the short time of their complete

union, the master-hand, the second the poet-soul, the third the conscience of the group? A similar puzzle would await him who should strive to unravel the delicate thread which winds itself round the artistic relation between Frederick Walker and the noted landscapist Mr. J.W. North. Though we at once recognise Walker as the dominant spirit, and see his influence even to-day, more than twenty years after his death, affirmed rather than weakened, there are certain characteristics of the style recognised and imitated as his, of which it would be unsafe to declare that he and not his companion originated them.

In days of artistic upheaval and growth like the last years of the fifteenth century and the first years of the sixteenth, the milieu must count for a great deal. It must be remembered that the men who most influence a time, whether in art or letters, are just those who, deeply rooted in it, come forth as its most natural development. Let it not be doubted that when in Giorgione's breast had been lighted the first sparks of the Promethean fire, which, with the soft intensity of its glow, warmed into full-blown perfection the art of Venice, that fire ran like lightning through the veins of all the artistic youth, his contemporaries and juniors, just because their blood was of the stuff to ignite and flame like his own.

The great Giorgionesque movement in Venetian art was not a question merely of school, of standpoint, of methods adopted and developed by a brilliant galaxy of young painters. It was not alone that "they who were excellent confessed, that he (Giorgione) was born to put the breath of life into painted figures, and to imitate the elasticity and colour of flesh, etc."[7] It was also that the Giorgionesque in conception and style was the outcome of the moment in art and life, just as the Pheidian

mode had been the necessary climax of Attic art and Attic life aspiring to reach complete perfection in the fifth century B.C.; just as the Raphaelesque appeared the inevitable outcome of those elements of lofty generalisation, divine harmony, grace clothing strength, which, in Florence and Rome, as elsewhere in Italy, were culminating in the first years of the Cinquecento. This was the moment, too, when—to take one instance only among many—the Ex-Queen of Cyprus, the noble Venetian Caterina Cornaro, held her little court at Asolo, where, in accordance with the spirit of the moment, the chief discourse was ever of love. In that reposeful kingdom, which could in miniature offer to Caterina's courtiers all the pomp and charm without the drawbacks of sovereignty, Pietro Bembo wrote for "Madonna Lucretia Estense Borgia Duchessa illustrissima di Ferrara," and caused to be printed by Aldus Manutius, the leaflets which, under the title Gli Asolani, ne' quali si ragiona d' amore,[8] soon became a famous book in Italy.

[Illustration: The Man of Sorrows. In the Scuola di S. Rocco, Venice. From a Photograph by Naya.]

The most Bellinesque work of Titian's youth with which we are acquainted is the curious Man of Sorrows of the Scuola di S. Rocco at Venice, a work so faded, so injured by restoration that to dogmatise as to its technique would be in the highest degree unsafe. The type approaches, among the numerous versions of the Pieta by and ascribed to Giovanni Bellini, most nearly to that in the Palazzo del Commune at Rimini. Seeing that Titian was in 1500 twenty-three years old, and a student of painting of some thirteen years' standing, there may well exist, or at any rate there may well have existed, from his hand things in a yet earlier and more distinctively Quattrocento-style than anything with

which we are at present acquainted. This Man of Sorrows itself may well be a little earlier than 1500, but on this point it is not easy to form a definite conclusion. Perhaps it is reserved in the future to some student uniting the qualities of patience and keen insight to do for the youthful Titian what Morelli and his school have done for Correggio—that is, to restore to him a series of paintings earlier in date than those which criticism has, up to the present time, been content to accept as showing his first independent steps in art. Everything else that we can at present safely attribute to the youthful Vecelli is deeply coloured with the style and feeling of Giorgione, though never, as is the case with the inferior Giorgionesques, so entirely as to obliterate the strongly marked individuality of the painter himself. The Virgin and Child in the Imperial Gallery of Vienna, popularly known as La Zingarella, which, by general consent, is accepted as the first in order of date among the works of this class, is still to a certain extent Bellinesque in the mode of conception and arrangement. Yet, in the depth, strength, and richness of the colour-chord, in the atmospheric spaciousness and charm of the landscape background, in the breadth of the draperies, it is already Giorgionesque. Nay, even here Titian, above all, asserts himself, and lays the foundation of his own manner. The type of the divine Bambino differs widely from that adopted by Giorgione in the altar-pieces of Castelfranco and the Prado Museum at Madrid. The virgin is a woman beautified only by youth and intensity of maternal love. Both Giorgione and Titian in their loveliest types of womanhood are sensuous as compared with the Tuscans and Umbrians, or with such painters as Cavazzola of Verona and the suave Milanese, Bernardino Luini. But Giorgione's sensuousness is that which may fitly characterise the goddess, while Titian's is that of the woman, much nearer to the everyday world in which both artists lived.

In the Imperial Gallery of the Hermitage at St. Petersburg is a beautiful Madonna and Child in a niche of coloured marble mosaic, which is catalogued as an early Titian under the influence of Giovanni Bellini. Judging only from the reproduction on a large scale done by Messrs. Braun and Co., the writer has ventured to suggest elsewhere[9]—prefacing his suggestions with the avowal that he is not acquainted with the picture itself—that we may have here, not an early Titian, but that rarer thing an early Giorgione. From the list of the former master's works it must at any rate be struck out, as even the most superficial comparison with, for instance, La Zingarella suffices to prove. In the notable display of Venetian art made at the New Gallery in the winter of 1895 were included two pictures (Nos. 1 and 7 in the catalogue) ascribed to the early time of Titian and evidently from the same hand. These were a Virgin and Child from the collection, so rich in Venetian works, of Mr. R.H. Benson (formerly among the Burghley House pictures), and a less well-preserved Virgin and Child with Saints from the collection of Captain Holford at Dorchester House. The former is ascribed by Crowe and Cavalcaselle to the early time of the master himself.[10] Both are, in their rich harmony of colour and their general conception, entirely Giorgionesque. They reveal the hand of some at present anonymous Venetian of the second order, standing midway between the young Giorgione and the young Titian—one who, while imitating the types and the landscape of these greater contemporaries of his, replaced their depth and glow by a weaker, a more superficial prettiness, which yet has its own suave charm.

[Illustration: Virgin and Child, known as "La Zingarella." Imperial Gallery, Vienna. From a Photograph by Loewy.]

The famous Christ bearing the Cross in the Chiesa di S. Rocco at Venice is first, in his Life of the Castelfranco painter, ascribed by Vasari to Giorgione, and then in the subsequent Life of Titian given to that master, but to a period very much too late in his career. The biographer quaintly adds: "This figure, which many have believed to be from the hand of Giorgione, is to-day the most revered object in Venice, and has received more charitable offerings in money than Titian and Giorgione together ever gained in the whole course of their life." This too great popularity of the work as a wonder-working picture is perhaps the cause that it is to-day in a state as unsatisfactory as is the Man of Sorrows in the adjacent Scuola. The picture which presents "Christ dragged along by the executioner, with two spectators in the background," resembles most among Giorgione's authentic creations the Christ bearing the Cross in the Casa Loschi at Vicenza. The resemblance is not, however, one of colour and technique, since this last—one of the earliest of Giorgiones—still recalls Giovanni Bellini, and perhaps even more strongly Cima; it is one of type and conception. In both renderings of the divine countenance there is—or it may be the writer fancies that there is—underlying that expression of serenity and humiliation accepted which is proper to the subject, a sinister, disquieting look, almost a threat. Crowe and Cavalcaselle have called attention to a certain disproportion in the size of the head, as compared with that of the surrounding actors in the scene. A similar disproportion is to be observed in another early Titian, the Christ between St. Andrew and St. Catherine in the Church of SS. Ermagora and Fortunato (commonly called S. Marcuola) at Venice. Here the head of the infant Christ, who stands on a pedestal holding the Orb, between the two saints above mentioned, is strangely out of proportion to the rest. Crowe and

Cavalcaselle had refused to accept this picture as a genuine Titian (vol. ii), but Morelli restored it to its rightful place among the early works.

Next to these paintings, and certainly several years before the Three Ages and the Sacred and Profane Love, the writer is inclined to place the Bishop of Paphos (Baffo) recommended by Alexander VI. to St. Peter, once in the collection of Charles I.[11] and now in the Antwerp Gallery. The main elements of Titian's art may be seen here, in imperfect fusion, as in very few even of his early productions. The not very dignified St. Peter, enthroned on a kind of pedestal adorned with a high relief of classic design, of the type which we shall find again in the Sacred and Profane Love, recalls Giovanni Bellini, or rather his immediate followers; the magnificently robed Alexander VI. (Rodrigo Borgia), wearing the triple tiara, gives back the style in portraiture of Gentile Bellini and Carpaccio; while the kneeling Jacopo Pesaro—an ecclesiastic in tonsure and vesture, but none the less a commander of fleets, as the background suggests—is one of the most characteristic portraits of the Giorgionesque school. Its pathos, its intensity, contrast curiously with the less passionate absorption of the same Baffo in the renowned Madonna di Casa Pesaro, painted twenty-three years later for the family chapel in the great Church of the Frari. It is the first in order of a great series, including the Ariosto of Cobham, the Jeune Homme au Gant, the Portrait of a Man in the Alte Pinakothek of Munich, and perhaps the famous Concert of the Pitti, ascribed to Giorgione. Both Crowe and Cavalcaselle and M. Georges Lafenestre[12] have called attention to the fact that the detested Borgia Pope died on the 18th of August 1503, and that the work cannot well have been executed after that time. He would have been a bold man who should have attempted to introduce

the portrait of Alexander VI. into a votive picture painted immediately after his death! How is it possible to assume, as the eminent critics do nevertheless assume, that the Sacred and Profane Love, one of the masterpieces of Venetian art, was painted one or two years earlier still, that is, in 1501 or, at the latest, in 1502? Let it be remembered that at that moment Giorgione himself had not fully developed the Giorgionesque. He had not painted his Castelfranco altar-piece, his Venus, or his Three Philosophers (Aeneas, Evander, and Pallas). Old Gian Bellino himself had not entered upon that ultimate phase of his art which dates from the great S. Zaccaria altar-piece finished in 1505.[13]

It is impossible on the present occasion to give any detailed account of the fresco decorations painted by Giorgione and Titian on the facades of the new Fondaco de' Tedeschi, erected to replace that burnt down on the 28th of January 1505. Full particulars will be found in Crowe and Cavalcaselle's often-quoted work. Vasari's many manifest errors and disconcerting transpositions in the biography of Titian do not predispose us to give unlimited credence to his account of the strained relations between Giorgione and our painter, to which this particular business is supposed to have given rise. That they together decorated with a series of frescoes which acquired considerable celebrity the exterior of the Fondaco is all that is known for certain, Titian being apparently employed as the subordinate of his friend and master. Of these frescoes only one figure, doubtfully assigned to Titian, and facing the Grand Canal, has been preserved, in a much-damaged condition—the few fragments that remained of those facing the side canal having been destroyed in 1884.[14] Vasari shows us a Giorgione angry because he has been complimented by friends on the superior beauty of some

work on the "facciata di verso la Merceria," which in reality belongs to Titian, and thereupon implacably cutting short their connection and friendship. This version is confirmed by Dolce, but refuted by the less contemporary authority of Tizianello's Anonimo. Of what great painters, standing in the relation of master and pupil, have not such stories been told, and—the worst of it is—told with a certain foundation of truth? Apocryphal is, no doubt, that which has evolved itself from the internal evidence supplied by the Baptism of Christ of Verrocchio and Leonardo da Vinci; but a stronger substructure of fact supports the unpleasing anecdotes as to Titian and Tintoretto, as to Watteau and Pater, as to our own Hudson and Reynolds, and, alas! as to very many others. How touching, on the other hand, is that simple entry in Francesco Francia's day-book, made when his chief journeyman, Timoteo Viti, leaves him: "1495 a di 4 aprile e partito il mio caro Timoteo; chi Dio li dia ogni bene et fortuna!" ("On the 4th day of April 1495 my dear Timoteo left me. May God grant him all happiness and good fortune!")

[Illustration: The Baptism of Christ. Gallery of the Capitol, Rome. From a Photograph by Anderson.]

There is one reason that makes it doubly difficult, relying on developments of style only, to make, even tentatively, a chronological arrangement of Titian's early works. This is that in those painted poesie of the earlier Venetian art of which the germs are to be found in Giovanni Bellini and Cima, but the flower is identified with Giorgione, Titian surrendered himself to the overmastering influence of the latter with less reservation of his own individuality than in his sacred works. In the earlier imaginative subjects the vivifying glow of Giorgionesque poetry

moulds, colours, and expands the genius of Titian, but so naturally as neither to obliterate nor to constrain it. Indeed, even in the late time of our master—checking an unveiled sensuousness which sometimes approaches dangerously near to a downright sensuality—the influence of the master and companion who vanished half a century before victoriously reasserts itself. It is this renouveau of the Giorgionesque in the genius of the aged Titian that gives so exquisite a charm to the Venere del Pardo, so strange a pathos to that still later Nymph and Shepherd, which was a few years ago brought out of its obscurity and added to the treasures of the Imperial Gallery at Vienna.

The sacred works of the early time are Giorgionesque, too, but with a difference. Here from the very beginning there are to be noted a majestic placidity, a fulness of life, a splendour of representation, very different from the tremulous sweetness, the spirit of aloofness and reserve which informs such creations as the Madonna of Castelfranco and the Madonna with St. Francis and St. Roch of the Prado Museum. Later on, we have, leaving farther and farther behind the Giorgionesque ideal, the overpowering force and majesty of the Assunta, the true passion going hand-in-hand with beauty of the Louvre Entombment, the rhetorical passion and scenic magnificence of the St. Peter Martyr.

The Baptism of Christ, with Zuanne Ram as donor, now in the Gallery of the Capitol at Rome, had been by Crowe and Cavalcaselle taken away from Titian and given to Paris Bordone, but the keen insight of Morelli led him to restore it authoritatively, and once for all, to Titian. Internal evidence is indeed conclusive in this case that the picture must be assigned to a date when Bordone was but a child of tender years.[15] Here Titian

is found treating this great scene in the life of Christ more in the style of a Giorgionesque pastoral than in the solemn hieratic fashion adopted by his great predecessors and contemporaries. The luxuriant landscape is in the main Giorgionesque, save that here and there a naked branch among the leafage—and on one of them the woodpecker—strongly recalls Giovanni Bellini. The same robust, round-limbed young Venetian, with the inexpressive face, does duty here as St. John the Baptist, who in the Three Ages, presently to be discussed, appears much more appropriately as the amorous shepherd. The Christ, here shown in the flower of youthful manhood, with luxuriant hair and softly curling beard, will mature later on into the divine Cristo della Moneta. The question at once arises here, Did Titian in the type of this figure derive inspiration from Giovanni Bellini's splendid Baptism of Christ, finished in 1510 for the Church of S. Corona at Vicenza, but which the younger artist might well have seen a year or two previously, while it was in the course of execution in the workshop of the venerable master? Apart from its fresh naivete, and its rare pictorial charm, how trivial and merely anecdotic does the conception of Titian appear by the side of that of Bellini, so lofty, so consoling in its serene beauty, in the solemnity of its sunset colour![16] Alone in the profile portrait of the donor, Zuanne Ram, placed in the picture with an awkwardness attractive in its naivete, but superbly painted, is Titian already a full-grown master standing alone.

The beautiful Virgin and Child with SS. Ulfo and Brigida, placed in the Sala de la Reina Isabel of the Prado, is now at last officially restored to Titian, after having been for years innumerable ascribed to Giorgione, whose style it not more than generally recalls. Here at any rate all the rival wise men are agreed, and it only remains for the student of the old masters,

working to-day on the solid substructure provided for him by his predecessors, to wonder how any other attribution could have been accepted. But then the critic of the present day is a little too prone to be wise and scornful a ban marche, forgetting that he has been spared three parts of the road, and that he starts for conquest at the high point, to reach which the pioneers of scientific criticism in art have devoted a lifetime of noble toil. It is in this piece especially that we meet with that element in the early art of the Cadorine which Crowe and Cavalcaselle have defined as "Palmesque." The St. Bridget and the St. Ulphus are both types frequently to be met with in the works of the Bergamasque painter, and it has been more than once remarked that the same beautiful model with hair of wavy gold must have sat to Giorgione, Titian, and Palma. This can only be true, however, in a modified sense, seeing that Giorgione did not, so much as his contemporaries and followers, affect the type of the beautiful Venetian blond, "large, languishing, and lazy." The hair of his women—both the sacred personages and the divinities nominally classic or wholly Venetian—is, as a rule, of a rich chestnut, or at the most dusky fair, and in them the Giorgionesque oval of the face tempers with its spirituality the strength of physical passion that the general physique denotes. The polished surface of this panel at Madrid, the execution, sound and finished without being finicking, the high yellowish lights on the crimson draperies, are all very characteristic of this, the first manner of Vecelli. The green hangings at the back of the picture are such as are very generally associated with the colour-schemes of Palma. An old repetition, with a slight variation in the Bambino, is in the royal collection at Hampton Court, where it long bore—indeed it does so still on the frame—the name of Palma Vecchio.

It will be remembered that Vasari assigns to the Tobias and the Angel in the Church of S. Marciliano at Venice the exact date 1507, describing it, moreover, with greater accuracy than he does any other work by Titian. He mentions even "the thicket, in which is a St. John the Baptist kneeling as he prays to heaven, whence comes a splendour of light." The Aretine biographer is followed in this particular by Morelli, usually so eagle-eyed, so little bound by tradition in tracing the beginnings of a great painter. The gifted modern critic places the picture among the quite early works of our master. Notwithstanding this weight of authority, the writer feels bound to dissent from the view just now indicated, and in this instance to follow Crowe and Cavalcaselle, who assign to the Tobias and the Angel a place much later on in Titian's long career. The picture, though it hangs high in the little church for which it was painted, will speak for itself to those who interrogate it without parti pris. Neither in the figures—the magnificently classic yet living archangel Raphael and the more naive and realistic Tobias—nor in the rich landscape with St. John the Baptist praying is there anything left of the early Giorgionesque manner. In the sweeping breadth of the execution, the summarising power of the brush, the glow from within of the colour, we have so many evidences of a style in its fullest maturity. It will be safe, therefore, to place the picture well on in Titian's middle period.[17]

The Three Ages in the Bridgewater Gallery and the so-called Sacred and Profane Love in the Borghese Gallery represent the apogee of Titian's Giorgionesque style. Glowing through and through with the spirit of the master-poet among Venetian painters, yet falling short a little, it may be, of that subtle charm of his, compounded indefinably of sensuous delight and spiritual yearning, these two masterpieces carry the Giorgionesque technically a pretty wide step farther than the inventor of the

style took it. Barbarelli never absolutely threw off the trammels of the Quattrocento, except in his portraits, but retained to the last—not as a drawback, but rather as an added charm—the naivete, the hardly perceptible hesitation proper to art not absolutely full-fledged.

The Three Ages, from its analogies of type and manner with the Baptism of the Capitol, would appear to be the earlier of the two imaginative works here grouped together, but to date later than that picture.[18] The tonality of the picture is of an exquisite silveriness—that of clear, moderate daylight, though this relative paleness may have been somewhat increased by time. It may a little disconcert at first sight those who have known the lovely pastoral only from hot, brown copies, such as the one which, under the name of Giorgione, was formerly in the Dudley House Collection, and now belongs to Sir William Farrer. It is still so difficult to battle with the deeply-rooted notion that there can be no Giorgione, no painting of his school, without the accompaniment of a rich brown sauce! The shepherdess has a robe of fairest crimson, and her flower-crowned locks in tint more nearly approach to the blond cendre which distinguishes so many of Palma's donne than to the ruddier gold that Titian himself generally affects. The more passionate of the two, she gazes straight into the eyes of her strong-limbed rustic lover, who half-reclining rests his hand upon her shoulder. On the twin reed-pipes, which she still holds in her hands, she has just breathed forth a strain of music, and to it, as it still lingers in their ears, they yield themselves entranced. Here the youth is naked, the maid clothed and adorned—a reversal, this, of Giorgione's Fete Champetre in the Salon Carre of the Louvre, where the women are undraped, and the amorous young cavaliers appear in complete and rich attire. To the right are a group of thoroughly Titianesque amorini—the winged

one, dominating the others, being perhaps Amor himself; while in the distance an old man contemplates skulls ranged round him on the ground—obvious reminders of the last stage of all, at which he has so nearly arrived. There is here a wonderful unity between the even, unaccented harmony of the delicate tonality and the mood of the personages—the one aiding the other to express the moment of pause in nature and in love, which in itself is a delight more deep than all that the very whirlwind of passion can give. Near at hand may be pitfalls, the smiling love-god may prove less innocent than he looks, and in the distance Fate may be foreshadowed by the figure of weary Age awaiting Death. Yet this one moment is all the lovers' own, and they profane it not by speech, but stir their happy languor only with faint notes of music borne on the still, warm air.

[Illustration: The Three Ages. Bridgewater Gallery. From the Plate in Lafenestre's "Vie et Oeuvre du Titien" (May, Paris.)]

The Sacred and Profane Love of the Borghese Gallery is one of the world's pictures, and beyond doubt the masterpiece of the early or Giorgionesque period. To-day surely no one will be found to gainsay Morelli when he places it at the end of that period, which it so incomparably sums up—not at the beginning, when its perfection would be as incomprehensible as the less absolute achievement displayed in other early pieces which such a classification as this would place after the Borghese picture. The accompanying reproduction obviates all necessity for a detailed description. Titian painted afterwards perhaps more wonderfully still—with a more sweeping vigour of brush, with a higher authority, and a play of light as brilliant and diversified. He never attained to a higher finish and perfection of its kind, or more admirably suited the technical means to the thing to be

achieved. He never so completely gave back, coloured with the splendour of his own genius, the rays received from Giorgione. The delicious sunset landscape has all the Giorgionesque elements, with more spaciousness, and lines of a still more suave harmony. The grand Venetian donna who sits sumptuously robed, flower-crowned, and even gloved, at the sculptured classic fount is the noblest in her pride of loveliness, as she is one of the first, of the long line of voluptuous beauties who will occupy the greatest brushes of the Cinquecento. The little love-god who, insidiously intervening, paddles in the water of the fountain and troubles its surface, is Titian's very own, owing nothing to any forerunner. The divinely beautiful Profane Love—or, as we shall presently see, Venus—is the most flawless presentment of female loveliness unveiled that modern art has known up to this date, save only the Venus of Giorgione himself (in the Dresden Gallery), to which it can be but little posterior. The radiant freshness of the face, with its glory of half-unbound hair, does not, indeed, equal the sovereign loveliness of the Dresden Venus or the disquieting charm of the Giovanelli Zingarella (properly Hypsipyle). Its beauty is all on the surface, while theirs stimulates the imagination of the beholder. The body with its strong, supple beauty, its unforced harmony of line and movement, with its golden glow of flesh, set off in the true Giorgionesque fashion by the warm white of the slender, diaphanous drapery, by the splendid crimson mantle with the changing hues and high lights, is, however, the most perfect poem of the human body that Titian ever achieved. Only in the late Venere del Pardo, which so closely follows the chief motive of Giorgione's Venus, does he approach it in frankness and purity. Far more genuinely classic is it in spirit, because more living and more solidly founded on natural truth, than anything that the Florentine or Roman schools, so much more assiduous in their study of classical antiquity, have brought forth.[19]

[Illustration: Sacred and Profane Love.]

It is impossible to discuss here in detail all the conjectural explanations which have been hazarded with regard to this most popular of all Venetian pictures—least of all that strange one brought forward by Crowe and Cavalcaselle, the Artless and Sated Love, for which they have found so little acceptance. But we may no longer wrap ourselves in an atmosphere of dreamy conjecture and show but a languid desire to solve the fascinating problem. Taking as his starting-point the pictures described by Marcantonio Michiel (the Anonimo of Jacopo Morelli), in the house of Messer Taddeo Contarini of Venice, as the Inferno with Aeneas and Anchises and Landscape with the Birth of Paris, Herr Franz Wickhoff[20] has proceeded, we have seen, to rename, with a daring crowned by a success nothing short of surprising, several of Barbarelli's best known works. The Three Philosophers he calls Aeneas, Evander, and Pallas, the Giovanelli Tempest with the Gipsy and the Soldier he explains anew as Admetus and Hypsipyle.[21] The subject known to us in an early plate of Marcantonio Raimondi, and popularly called, or rather miscalled, the Dream of Raphael, is recognised by Herr Wickhoff as having its root in the art of Giorgione. He identifies the mysterious subject with one cited by Servius, the commentator of Virgil, who relates how, when two maidens were sleeping side by side in the Temple of the Penates at Lavinium (as he puts it), the unchaste one was killed by lightning, while the other remained in peaceful sleep.

Passing over to the Giorgionesque period of Titian, he boldly sets to work on the world-famous Sacred and Profane Love, and shows us the Cadorine painter interpreting, at the suggestion of

some learned humanist at his elbow, an incident in the Seventh Book of the Argonautica of Valerius Flaccus—that wearisome imitation of the similarly named epic of Apollonius Rhodius. Medea—the sumptuously attired dame who does duty as Sacred Love(!)—sits at the fountain in unrestful self-communing, leaning one arm on a mysterious casket, and holding in her right hand a bunch of wonder-working herbs. She will not yield to her new-born love for the Greek enemy Jason, because this love is the most shameful treason to father and people. But to her comes Venus in the form of the sorceress Circe, the sister of Medea's father, irresistibly pleading that she shall go to the alien lover, who waits in the wood. It is the vain resistance of Medea, hopelessly caught in the toils of love, powerless for all her enchantments to resist, it is the subtle persuasion of Venus, seemingly invisible—in Titian's realisation of the legend—to the woman she tempts, that constitute the main theme upon which Titian has built his masterpiece. Moritz Thausing[22] had already got half-way towards the unravelling of the true subject when he described the Borghese picture as The Maiden with Venus and Amor at the Well. The vraisemblance of Herr Wickhoff's brilliant interpretation becomes the greater when we reflect that Titian at least twice afterwards borrowed subjects from classical antiquity, taking his Worship of Venus, now at Madrid, from the Erotes of Philostratus, and our own wonderful Bacchus and Ariadne at the National Gallery from the Epithalamium Pelei et Thetidos of Catullus. In the future it is quite possible that the Austrian savant may propose new and precise interpretations for the Three Ages and for Giorgione's Concert Champetre at the Louvre.

[Illustration: Herodias with the Head of John the Baptist. Doria Gallery, Rome. From the Replica in the Collection of R.H. Benson, Esq.]

It is no use disguising the fact that, grateful as the true student of Italian art must be for such guidance as is here given, it comes to him at first as a shock that these mysterious creations of the ardent young poet-painters, in the presence of which we have most of us so willingly allowed reason and argument to stand in abeyance, should thus have hard, clear lines drawn, as it were, round their deliciously vague contours. It is their very vagueness and strangeness, the atmosphere of pause and quiet that they bring with them, the way in which they indefinably take possession of the beholder, body and soul, that above and beyond their radiant beauty have made them dear to successive generations. And yet we need not mourn overmuch, or too painfully set to work to revise our whole conception of Venetian idyllic art as matured in the first years of the Cinquecento. True, some humanist of the type of Pietro Bembo, not less amorous than learned and fastidious, must have found for Titian and Giorgione all these fine stories from Virgil, Catullus, Statius, and the lesser luminaries of antique poetry, which luckily for the world they have interpreted in their own fashion. The humanists themselves would no doubt have preferred the more laborious and at the same time more fantastic Florentine fashion of giving plastic form in every particular to their elaborate symbolisms, their artificial conceits, their classic legends. But we may unfeignedly rejoice that the Venetian painters of the golden prime disdained to represent—or it may be unconsciously shrank from representing—the mere dramatic moment, the mere dramatic and historical character of a subject thus furnished to them. Giorgione embodies in such a picture as the Adrastus and Hypsipyle, or the Aeneas and Evander, not so much what has been related to him of those ancient legends as his own mood when he is brought into contact with them; he

transposes his motive from a dramatic into a lyrical atmosphere, and gives it forth anew, transformed into something "rich and strange," coloured for ever with his own inspired yet so warmly human fantasy. Titian, in the Sacred and Profane Love, as for identification we must still continue to call it, strives to keep close to the main lines of his story, in this differing from Giorgione. But for all that, his love for the rich beauty of the Venetian country, for the splendour of female loveliness unveiled, for the piquant contrast of female loveliness clothed and sumptuously adorned, has conquered. He has presented the Romanised legend of the fair Colchian sorceress in such a delightfully misleading fashion that it has taken all these centuries to decipher its true import. What Giorgione and Titian in these exquisite idylls—for so we may still dare to call them—have consciously or unconsciously achieved, is the indissoluble union of humanity outwardly quiescent, yet pulsating with an inner life and passion, to the environing nature. It is Nature herself that in these true painted poems mysteriously responds, that interprets to the beholder the moods of man, much as a mighty orchestra—Nature ordered and controlled—may by its undercurrent explain to him who knows how to listen what the very personages of the drama may not proclaim aloud for themselves. And so we may be deeply grateful to Herr Wickhoff for his new interpretations, not less sound and thoroughly worked out than they are on a first acquaintance startling. And yet we need not for all that shatter our old ideals, or force ourselves too persistently to look at Venetian art from another and a more prosaic, because a more precise and literal, standpoint.

[Illustration: Vanitas. Alte Pinakothek, Munich. From a Photograph by Hanfstaengl.]

CHAPTER II

Frescoes of the Scuola del Santo—The "Herodias" type of picture—Holy Families and Sacred Conversations—Date of the "Cristo della Moneta" Is the "Concert" of the Pitti by Titian?—The "Bacchanal" of Alnwick Castle.

It has been pointed out by Titian's biographers that the wars which followed upon the League of Cambrai had the effect of dispersing all over North Italy the chief Venetian artists of the younger generation. It was not long after this—on the death of his master Giorgione—that Sebastiano Luciani migrated to Rome and, so far as he could, shook off his allegiance to the new Venetian art; it was then that Titian temporarily left the city of his adoption to do work in fresco at Padua and Vicenza. If the date 1508, given by Vasari for the great frieze-like wood-engraving, The Triumph of Faith, be accepted, it must be held that it was executed before the journey to Padua. Ridolfi[23] cites

painted compositions of the Triumph as either the originals or the repetitions of the wood-engravings, for which Titian himself drew the blocks. The frescoes themselves, if indeed Titian carried them out on the walls of his house at Padua, as has been suggested, have perished; but that they ever came into existence there would not appear to be any direct evidence. The types, though broadened and coarsened in the process of translation into wood-engraving, are not materially at variance with those in the frescoes of the Scuola del Santo. But the movement, the spirit of the whole is essentially different. This mighty, onward-sweeping procession, with Adam and Eve, the Patriarchs, the Prophets and Sibyls, the martyred Innocents, the great chariot with Christ enthroned, drawn by the four Doctors of the Church and impelled forward by the Emblems of the four Evangelists, with a great company of Apostles and Martyrs following, has all the vigour and elasticity, all the decorative amplitude that is wanting in the frescoes of the Santo. It is obvious that inspiration was derived from the Triumphs of Mantegna, then already so widely popularised by numerous engravings. Titian and those under whose inspiration he worked here obviously intended an antithesis to the great series of canvases presenting the apotheosis of Julius Caesar, which were then to be seen in the not far distant Mantua. Have we here another pictorial commentary, like the famous Cristo detta Moneta, with which we shall have to deal presently, on the "Quod est Caesaris Caesari, quod est Dei Deo," which was the favourite device of Alfonso of Ferrara and the legend round his gold coins? The whole question is interesting, and deserves more careful consideration than can be accorded to it on the present occasion. Hardly again, until he reached extreme old age, did such an impulse of sacred passion colour the art of the painter of Cadore

as here. In the earlier section of his life-work the Triumph of Faith constitutes a striking exception.

[Illustration: St. Anthony of Padua causing a new-born Infant to speak. Fresco in the Scuola del Santo, Padua. From a Photograph by Alinari.]

Passing over, as relatively unimportant, Titian's share in the much-defaced fresco decorations of the Scuola del Carmine, we come now to those more celebrated ones in the Scuola del Santo. Out of the sixteen frescoes executed in 1510-11 by Titian, in concert with Domenico Campagnola and other assistants of less fame, the following three are from the brush of the master himself:—St. Anthony causes a new-born Infant to speak, testifying to the innocence of its Mother; St. Anthony heals the leg of a Youth; A jealous Husband puts to death his Wife, whom the Saint afterwards restores to life. Here the figures, the composition, the beautiful landscape backgrounds bear unmistakably the trace of Giorgione's influence. The composition has just the timidity, the lack of rhythm and variety, that to the last marks that of Barbarelli. The figures have his naive truth, his warmth and splendour of life, but not his gilding touch of spirituality to lift the uninspiring subjects a little above the actual. The Nobleman putting to death his Wife is dramatic, almost terrible in its fierce, awkward realism, yet it does not rise much higher in interpretation than what our neighbours would to-day call the drame passionel. The interest is much the same that is aroused in a student of Elizabethan literature by that study of murder, Arden of Feversham, not that higher attraction that he feels—horrors notwithstanding—for The Maid's Tragedy of Beaumont and Fletcher, or The Duchess of Malfi of Webster.[24]

[Illustration: "Noli me tangere." National Gallery. From a Photograph published by the Autotype Company.]

A convenient date for the magnificent St. Mark enthroned, with SS. Sebastian, Roch, Cosmas, and Damianus, is 1512, when Titian, having completed his share of the work at the Scuola del Santo, returned to Venice. True, it is still thoroughly Giorgionesque, except in the truculent St. Mark; but, then, as essentially so were the frescoes just terminated. The noble altar-piece[25] symbolises, or rather commemorates, the steadfastness of the State face to face with the terrors of the League of Cambrai:—on the one side St. Sebastian, standing, perhaps, for martyrdom by superior force of arms, St. Roch for plague (the plague of Venice in 1510); on the other, SS. Cosmas and Damianus, suggesting the healing of these evils. The colour is Giorgionesque in that truer sense in which Barbarelli's own is so to be described. Especially does it show points of contact with that of the so-called Three Philosophers, which, on the authority of Marcantonio Michiel (the Anonimo), is rightly or wrongly held to be one of the last works of the Castelfranco master. That is to say, it is both sumptuous and boldly contrasted in the local hues, the sovereign unity of general tone not being attained by any sacrifice or attenuation, by any undue fusion of these, as in some of the second-rate Giorgionesques. Common to both is the use of a brilliant scarlet, which Giorgione successfully employs in the robe of the Trojan Aeneas, and Titian on a more extensive scale in that of one of the healing saints. These last are among the most admirable portrait-figures in the life-work of Titian. In them a simplicity, a concentration akin to that of Giovanni Bellini and Bartolommeo Montagna is combined with the suavity and flexibility of Barbarelli. The St. Sebastian is the

most beautiful among the youthful male figures, as the Venus of Giorgione and the Venus of the Sacred and Profane Love are the most beautiful among the female figures to be found in the Venetian art of a century in which such presentments of youth in its flower abounded. There is something androgynous, in the true sense of the word, in the union of the strength and pride of lusty youth with a grace which is almost feminine in its suavity, yet not offensively effeminate. It should be noted that a delight in portraying the fresh comeliness, the elastic beauty of form proper to the youth just passing into the man was common to many Venetian painters at this stage, and coloured their art as it had coloured the whole art of Greece.

Hereabouts the writer would like to place the singularly attractive, yet a little puzzling, Madonna and Child with St. Joseph and a Shepherd, which is No. 4 in the National Gallery. The type of the landscape is early, and even for that time the execution in this particular is, for Titian, curiously small and wanting in breadth. Especially the projecting rock, with its fringe of half-bare shrubs profiled against the sky, recalls the backgrounds of the Scuola del Santo frescoes. The noble type and the stilted attitude of the St. Joseph suggest the St. Mark of the Salute. The frank note of bright scarlet in the jacket of the thick-set young shepherd, who calls up rather the downrightness of Palma than the idyllic charm of Giorgione, is to be found again in the Salute picture. The unusually pensive Madonna reminds the spectator, by a certain fleshiness and matronly amplitude of proportion, though by no means in sentiment, of the sumptuous dames who look on so unconcernedly in the St. Anthony causing a newborn Infant to speak, of the Scuola. Her draperies show, too, the jagged breaks and close parallel folds of the early time before complete freedom of design was attained.

[Illustration: St. Mark enthroned, with four Saints. S. Maria della Salute, Venice. From a Photograph by Anderson.]

[Illustration: The Madonna with the Cherries. Imperial Gallery, Vienna. From a Photograph by Loewy.]

The splendidly beautiful Herodias with the head of St. John the Baptist, in the Doria Gallery, formerly attributed to Pordenone, but by Morelli definitively placed among the Giorgionesque works of Titian, belongs to about the same time as the Sacred and Profane Love, and would therefore come in rather before than after the sojourn at Padua and Vicenza. The intention has been not so much to emphasise the tragic character of the motive as to exhibit to the highest advantage the voluptuous charm, the languid indifference of a Venetian beauty posing for Herod's baleful consort. Repetitions of this Herodias exist in the Northbrook Collection and in that of Mr. R.H. Benson. The latter, which is presumably from the workshop of the master, and shows variations in one or two unimportant particulars from the Doria picture, is here, failing the original, reproduced with the kind permission of the owner. A conception traceable back to Giorgione would appear to underlie, not only this Doria picture, but that Herodias which at Dorchester House is, for not obvious reasons, attributed to Pordenone, and another similar one by Palma Vecchio, of which a late copy exists in the collection of the Earl of Chichester. Especially is this community of origin noticeable in the head of St. John on the charger, as it appears in each of these works. All of them again show a family resemblance in this particular respect to the interesting full-length Judith at the Hermitage, now ascribed to Giorgione, to the over-painted half-length Judith in the Querini-Stampalia

Collection at Venice, and to Hollar's print after a picture supposed by the engraver to give the portrait of Giorgione himself in the character of David, the slayer of Goliath.[26] The sumptuous but much-injured Vanitas, which is No. 1110 in the Alte Pinakothek of Munich—a beautiful woman of the same opulent type as the Herodias, holding a mirror which reflects jewels and other symbols of earthly vanity—may be classed with the last-named work. Again we owe it to Morelli[27] that this painting, ascribed by Crowe and Cavalcaselle—as the Herodias was ascribed—to Pordenone, has been with general acceptance classed among the early works of Titian. The popular Flora of the Uffizi, a beautiful thing still, though all the bloom of its beauty has been effaced, must be placed rather later in this section of Titian's life-work, displaying as it does a technique more facile and accomplished, and a conception of a somewhat higher individuality. The model is surely the same as that which has served for the Venus of the Sacred and Profane Love, though the picture comes some years after that piece. Later still comes the so-called Alfonso d'Este and Laura Dianti, as to which something will be said farther on. Another puzzle is provided by the beautiful "Noli me tangere" of the National Gallery, which must necessarily have its place somewhere here among the early works. Giorgionesque the picture still is, and most markedly so in the character of the beautiful landscape; yet the execution shows an altogether unusual freedom and mastery for that period. The Magdalen is, appropriately enough, of the same type as the exquisite, golden blond courtezans—or, if you will, models—who constantly appear and reappear in this period of Venetian art. Hardly anywhere has the painter exhibited a more wonderful freedom and subtlety of brush than in the figure of the Christ, in which glowing flesh is so finely set off by the white of fluttering, half-transparent draperies. The canvas has exqui-

site colour, almost without colours; the only local tint of any very defined character being the dark red of the Magdalen's robe. Yet a certain affectation, a certain exaggeration of fluttering movement and strained attitude repel the beholder a little at first, and neutralise for him the rare beauties of the canvas. It is as if a wave of some strange transient influence had passed over Titian at this moment, then again to be dissipated.

[Illustration: Madonna and Child, with St. John and St. Anthony Abbot. Uffizi Gallery, Florence. From a Photograph by Brogi.]

But to turn now once more to the series of our master's Holy Families and Sacred Conversations which began with La Zingarella, and was continued with the Virgin and Child with SS. Ulfo and Brigida of Madrid. The most popular of all those belonging to this still early time is the Virgin with the Cherries in the Vienna Gallery. Here the painter is already completely himself. He will go much farther in breadth if not in polish, in transparency, in forcefulness, if not in attractiveness of colour; but he is now, in sacred art at any rate, practically free from outside influences. For the pensive girl-Madonna of Giorgione we now have the radiant young matron of Titian, joyous yet calm in her play with the infant Christ, while the Madonna of his master and friend was unrestful and full of tender foreboding even in seeming repose. Pretty close on this must have followed the Madonna and Child with St. Stephen, St. Ambrose and St. Maurice, No 439 in the Louvre, in which the rich colour-harmonies strike a somewhat deeper note. An atelier repetition of this fine original is No. 166 in the Vienna Gallery; the only material variation traceable in this last-named example being

that in lieu of St. Ambrose, wearing a kind of biretta, we have St. Jerome bareheaded.

Very near in time and style to this particular series, with which it may safely be grouped, is the beautiful and finely preserved Holy Family in the Bridgewater Gallery, where it is still erroneously attributed to Palma Vecchio. It is to be found in the same private apartment on the groundfloor of Bridgewater House, that contains the Three Ages. Deep glowing richness of colour and smooth perfection without smallness of finish make this picture remarkable, notwithstanding its lack of any deeper significance. Nor must there be forgotten in an enumeration of the early Holy Families, one of the loveliest of all, the Madonna and Child with the infant St. John and St. Anthony Abbot, which adorns the Venetian section of the Uffizi Gallery. Here the relationship to Giorgione is more clearly shown than in any of these Holy Families of the first period, and in so far the painting, which cannot be placed very early among them, constitutes a partial exception in the series. The Virgin is of a more refined and pensive type than in the Madonna with the Cherries of Vienna, or the Madonna with Saints, No. 439 in the Louvre, and the divine Bambino less robust in build and aspect. The magnificent St. Anthony is quite Giorgionesque in the serenity tinged with sadness of his contemplative mood.

[Illustration: From a photograph by Brauen-Clement & Cie. Virgin and Child with Saints.]

Last of all in this particular group—another work in respect of which Morelli has played the rescuer—is the Madonna and Child with four Saints, No. 168 in the Dresden Gallery, a much-injured but eminently Titianesque work, which may be

said to bring this particular series to within a couple of years or so of the Assunta—that great landmark of the first period of maturity. The type of the Madonna here is still very similar to that in the Madonna with the Cherries.

[Illustration: St. Eustace (or St. Hubert) with the Miracle of the Stag. From a Drawing by Titian in the British Museum.]

Apart from all these sacred works, and in every respect an exceptional production, is the world-famous Cristo della Moneta of the Dresden Gallery. As to the exact date to be assigned to this panel among the early works of Titian considerable difficulty exists. For once agreeing with Crowe and Cavalcaselle, Morelli is inclined to disregard the testimony of Vasari, from whose text it would result that it was painted in or after the year 1514, and to place it as far back as 1508. Notwithstanding this weight of authority the writer is strongly inclined, following Vasari in this instance, and trusting to certain indications furnished by the picture itself, to return to the date 1514 or thereabouts. There is no valid reason to doubt that the Christ of the Tribute-Money was painted for Alfonso I. of Ferrara, and the less so, seeing that it so aptly illustrates the already quoted legend on his coins: "Quod est Caesaris Caesari, quod est Dei Deo." According to Vasari, it was painted nella porta d'un armario—that is to say, in the door of a press or wardrobe. But this statement need not be taken in its most literal sense. If it were to be assumed from this passage that the picture was painted on the spot, its date must be advanced to 1516, since Titian did not pay his first visit to Ferrara before that year. There is no sufficient ground, however, for assuming that he did not execute his wonderful panel in the usual fashion—that is to say, at home in Venice. The last finishing touches might, perhaps, have been given to it in situ, as they

were to Bellini's Bacchanal, done also for the Duke of Ferrara. The extraordinary finish of the painting, which is hardly to be paralleled in this respect in the life-work of the artist, may have been due to his desire to "show his hand" to his new patron in a subject which touched him so nearly. And then the finish is not of the Quattrocento type, not such as we find, for instance, in the Leonardo Loredano of Giovanni Bellini, the finest panels of Cima, or the early Christ bearing the Cross of Giorgione. In it exquisite polish of surface and consummate rendering of detail are combined with the utmost breadth and majesty of composition, with a now perfect freedom in the casting of the draperies. It is difficult, indeed, to imagine that this masterpiece—so eminently a work of the Cinquecento, and one, too, in which the master of Cadore rose superior to all influences, even to that of Giorgione—could have been painted in 1508, that is some two years before Bellini's Baptism of Christ in S. Corona, and in all probability before the Three Philosophers of Giorgione himself. The one of Titian's own early pictures with which it appears to the writer to have most in common—not so much in technique, indeed, as in general style—is the St. Mark of the Salute, and than this it is very much less Giorgionesque. To praise the Cristo della Moneta anew after it has been so incomparably well praised seems almost an impertinence. The soft radiance of the colour so well matches the tempered majesty, the infinite mansuetude of the conception; the spirituality, which is of the essence of the august subject, is so happily expressed, without any sensible diminution of the splendour of Renaissance art approaching its highest. And yet nothing could well be simpler than the scheme of colour as compared with the complex harmonies which Venetian art in a somewhat later phase affected. Frank contrasts are established between the tender, glowing flesh of the Christ, seen in all the glory of achieved

manhood, and the coarse, brown skin of the son of the people who appears as the Pharisee; between the bright yet tempered red of His robe and the deep blue of His mantle. But the golden glow, which is Titian's own, envelops the contrasting figures and the contrasting hues in its harmonising atmosphere, and gives unity to the whole.[28]

[Illustration: The "Cristo della Moneta." Dresden Gallery. From a Photograph by Hanfstaengl.]

A small group of early portraits—all of them somewhat difficult to place—call for attention before we proceed. Probably the earliest portrait among those as yet recognised as from the hand of our painter—leaving out of the question the Baffo and the portrait-figures in the great St. Mark of the Salute—is the magnificent Ariosto in the Earl of Darnley's Collection at Cobham Hall.[29] There is very considerable doubt, to say the least, as to whether this half-length really represents the court poet of Ferrara, but the point requires more elaborate discussion than can be here conceded to it. Thoroughly Giorgionesque is the soberly tinted yet sumptuous picture in its general arrangement, as in its general tone, and in this respect it is the fitting companion and the descendant of Giorgione's Antonio Broccardo at Buda-Pesth, of his Knight of Malta at the Uffizi. Its resemblance, moreover, is, as regards the general lines of the composition, a very striking one to the celebrated Sciarra Violin-Player by Sebastiano del Piombo, now in the gallery of Baron Alphonse Rothschild at Paris, where it is as heretofore given to Raphael.[30] The handsome, manly head has lost both subtlety and character through some too severe process of cleaning, but Venetian art has hardly anything more magnificent to show than

the costume, with the quilted sleeve of steely, blue-grey satin which occupies so prominent a place in the picture.

[Illustration: Madonna and Child, with four Saints. Dresden Gallery. From a Photograph by Hanfstaengl.]

The so-called Concert of the Pitti Palace, which depicts a young Augustinian monk as he plays on a keyed instrument, having on one side of him a youthful cavalier in a plumed hat, on the other a bareheaded clerk holding a bass-viol, was, until Morelli arose, almost universally looked upon as one of the most typical Giorgiones.[31] The most gifted of the purely aesthetic critics who have approached the Italian Renaissance, Walter Pater, actually built round this Concert his exquisite study on the School of Giorgione. There can be little doubt, notwithstanding, that Morelli was right in denying the authorship of Barbarelli, and tentatively, for he does no more, assigning the so subtly attractive and pathetic Concert to the early time of Titian. To express a definitive opinion on the latter point in the present state of the picture would be somewhat hazardous. The portrait of the modish young cavalier and that of the staid elderly clerk, whose baldness renders tonsure impossible—that is just those portions of the canvas which are least well preserved—are also those that least conclusively suggest our master. The passion-worn, ultra-sensitive physiognomy of the young Augustinian is, undoubtedly, in its very essence a Giorgionesque creation, for the fellows of which we must turn to the Castelfranco master's just now cited Antonio Broccardo, to his male portraits in Berlin and at the Uffizi, to his figure of the youthful Pallas, son of Evander, in the Three Philosophers. Closer to it, all the same, are the Raffo and the two portraits in the St. Mark of the Salute, and closer still is the supremely fine

Jeune Homme au Gant of the Salon Carré, that later production of Vecelli's early time. The Concert of the Pitti, so far as it can be judged through the retouches that cover it, displays an art certainly not finer or more delicate, but yet in its technical processes broader, swifter, and more synthetic than anything that we can with certainty point to in the life-work of Barbarelli. The large but handsome and flexible hands of the player are much nearer in type and treatment to Titian than they are to his master. The beautiful motive—music for one happy moment uniting by invisible bonds of sympathy three human beings—is akin to that in the Three Ages, though there love steps in as the beautifier of rustic harmony. It is to be found also in Giorgione's Concert Champetre, in the Louvre, in which the thrumming of the lute is, however, one among many delights appealing to the senses. This smouldering heat, this tragic passion in which youth revels, looking back already with discontent, yet forward also with unquenchable yearning, is the keynote of the Giorgionesque and the early Titianesque male portraiture. It is summed up by the Antonio Broccardo of the first, by the Jeune Homme au Gant of the second. Altogether other, and less due to a reaction from physical ardour, is the exquisite sensitiveness of Lorenzo Lotto, who sees most willingly in his sitters those qualities that are in the closest sympathy with his own highly-strung nature, and loves to present them as some secret, indefinable woe tears at their heart-strings. A strong element of the Giorgionesque pathos informs still and gives charm to the Sciarra Violin-Player of Sebastiano del Piombo; only that there it is already tempered by the haughty self-restraint more proper to Florentine and Roman portraiture. There is little or nothing to add after this as to the Jeune Homme au Gant, except that as a representation of aristocratic youth it has hardly a parallel among the master's works except, perhaps, a later and equally admirable, though less distinguished, portrait in the Pitti.

[Illustration: From a Photograph by Brauen Clement & Cie. Walter L. Colls. ph. sc.

Jeune Homme au gant]

[Illustration: A Concert. Probably by Titian. Pitti Palace, Florence. From a Photograph by Alinari.]

Not until Van Dyck, refining upon Rubens under the example of the Venetians, painted in the pensieroso mood his portraits of high-bred English cavaliers in all the pride of adolescence or earliest manhood, was this particular aspect of youth in its flower again depicted with the same felicity.[32]

To Crowe and Cavalcaselle's pages the reader must be referred for a detailed and interesting account of Titian's intrigues against the venerable Giovanni Bellini in connection with the Senseria, or office of broker, to the merchants of the Fondaco de' Tedeschi. We see there how, on the death of the martial pontiff, Julius the Second, Pietro Bembo proposed to Titian to take service with the new Medici Pope, Leo the Tenth (Giovanni de' Medici), and how Navagero dissuaded him from such a step. Titian, making the most of his own magnanimity, proceeds to petition the Doge and Signori for the first vacant broker's patent for life, on the same conditions and with the same charges and exemptions as are conceded to Giovanni Bellini. The petition is presented on the 31st of May 1513, and the Council of Ten on that day moves and carries a resolution accepting Titian's offer with all the conditions attached. Though he has arrived at the extreme limit of his splendid career, old Gian Bellino, who has just given new proof of his still transcendent power in the great

altar-piece of S. Giovanni Crisostomo (1513), which is in some respects the finest of all his works, declines to sit still under the encroachments of his dangerous competitor, younger than himself by half a century. On the 24th of March 1514 the Council of Ten revokes its decree of the previous May, and formally declares that Titian is not to receive his broker's patent on the first vacancy, but must wait his turn. Seemingly nothing daunted, Titian petitions again, asking for the reversion of the particular broker's patent which will become vacant on the death of Giovanni Bellini; and this new offer, which stipulates for certain special payments and provisions, is accepted by the Council. Titian, like most other holders of the much-coveted office, shows himself subsequently much more eager to receive its not inconsiderable emoluments than to finish the pictures, the painting of which is the one essential duty attached to the office. Some further bargaining takes place with the Council on the 18th of January 1516, but, a few days after the death of Giovanni Bellini at the end of November in the same year, fresh resolutions are passed postponing the grant to Titian of Bellini's patent; notwithstanding which, there is conclusive evidence of a later date to show that he is allowed the full enjoyment of his "Senseria in Fontego di Tedeschi" (sic), with all its privileges and immunities, before the close of this same year, 1516.

[Illustration: Portrait of a Man. Alte Pinakothek, Munich. From a Photograph by Hanfstaengl.]

It is in this year that Titian paid his first visit to Ferrara, and entered into relations with Alfonso I., which were to become more intimate as the position of the master became greater and more universally recognised in Italy. It was here, as we may safely assume, that he completed, or, it may be, repaired, Giovanni

Bellini's last picture, the great Bacchanal or Feast of the Gods on Earth, now at Alnwick Castle. It is there that he obtained the commission for two famous works, the Worship of Venus and the Bacchanal, designed, in continuation of the series commenced with Bellini's Feast of the Gods, to adorn a favourite apartment in Alfonso's castle of Ferrara; the series being completed a little later on by that crown and climax of the whole set, the Bacchus and Ariadne of the National Gallery.

Bellini appears in an unfamiliar phase in this final production of his magnificent old age, on which the signature, together with the date, 1514, so carefully noted by Vasari, is still most distinctly to be read. Much less Giorgionesque—if the term be in this case permissible—and more Quattrocentist in style than in the immediately preceding altar-piece of S. Giovanni Crisostomo, he is here hardly less interesting. All admirers of his art are familiar with the four beautiful Allegories of the Accademia delle Belle Arti at Venice, which constitute, besides the present picture, almost his sole excursion into the regions of pagan mythology and symbolism. These belong, however, to a considerably earlier period of his maturity, and show a fire which in the Bacchanal has died out.[33] Vasari describes this Bacchanal as "one of the most beautiful works ever executed by Gian Bellino," and goes on to remark that it has in the draperies "a certain angular (or cutting) quality in accordance with the German style." He strangely attributes this to an imitation of Duerer's Rosenkranzfest, painted some eight years previously for the Church of San Bartolommeo, adjacent to the Fondaco de' Tedeschi. This particularity, noted by the author of the Vite, and, in some passages, a certain hardness and opacity of colour, give rise to the surmise that, even in the parts of the picture which belong to Bellini, the co-operation of Basaiti may be

traced. It was he who most probably painted the background and the figure of St. Jerome in the master's altar-piece finished in the preceding year for S. Giovanni Crisostomo; it was he, too, who to a great extent executed, though he cannot have wholly devised, the Bellinesque Madonna in Glory with Eight Saints in the Church of San Pietro Martire at Murano, which belongs to this exact period. Even in the Madonna of the Brera Gallery (1510), which shows Gian Bellino's finest landscape of the late time, certain hardnesses of colour in the main group suggest the possibility of a minor co-operation by Basaiti. Some passages of the Bacchanal, however—especially the figures of the two blond, fair-breasted goddesses or nymphs who, in a break in the trees, stand relieved against the yellow bands of a sunset sky—are as beautiful as anything that Venetian art in its Bellinesque phase has produced up to the date of the picture's appearance. Very suggestive of Bellini is the way in which the hair of some of the personages is dressed in heavy formal locks, such as can only be produced by artificial means. These are to be found, no doubt, chiefly in his earliest or Paduan period, when they are much more defined and rigid. Still this coiffure—for as such it must be designated—is to be found more or less throughout the master's career. It is very noticeable in the Allegories just mentioned.

[Illustration: Alessandro de' Medici (so called). Hampton Court. From a Photograph by Spooner & Co.]

Infinitely pathetic is the old master's vain attempt to infuse into the chosen subject the measure of Dionysiac vehemence that it requires. An atmosphere of unruffled peace, a grand serenity, unconsciously betraying life-weariness, replaces the amorous unrest that courses like fire through the veins of his artistic offspring, Giorgione and Titian. The audacious gestures and move-

ments naturally belonging to this rustic festival, in which the gods unbend and, after the homelier fashion of mortals, rejoice, are indicated; but they are here gone through, it would seem, only pour la forme. A careful examination of the picture substantially confirms Vasari's story that the Feast of the Gods was painted upon by Titian, or to put it otherwise, suggests in many passages a Titianesque hand. It may well be, at the same time, that Crowe and Cavalcaselle are right in their conjecture that what the younger master did was rather to repair injury to the last work of the elder and supplement it by his own than to complete a picture left unfinished by him. The whole conception, the charpente, the contours of even the landscape are attributable to Bellini. His are the carefully-defined, naked tree-trunks to the right, with above in the branches a pheasant, and on a twig, in the immediate foreground of the picture, a woodpecker; his is the rocky formation of the foreground with its small pebbles.[34] Even the tall, beetling crag, crowned with a castle sunset-lit—so confidently identified with the rock of Cadore and its castle—is Bellinesque in conception, though not in execution. By Titian, and brushed in with a loose breadth that might be taken to betray a certain impatience and lack of interest, are the rocks, the cloud-flecked blue sky, the uplands and forest-growth to the left, the upper part of the foliage that caps the hard, round tree-trunks to the right. If it is Titian that we have here, as certainly appears most probable, he cannot be deemed to have exerted his full powers in completing or developing the Bellinesque landscape. The task may well, indeed, have presented itself to him as an uninviting one. There is nothing to remind the beholder, in conception or execution, of the exquisite Giorgionesque landscapes in the Three Ages and the Sacred and Profane Love, while the broader handling suggests rather the technical style, but in no way the beauty of the sublime prospect which opens out in the Bacchus and Ariadne.

CHAPTER III

The "Worship of Venus" and "Bacchanal" Place in Art of the "Assunta"—The "Bacchus and Ariadne"—So-called Portraits of Alfonso of Ferrara and Laura Dianti—The "St. Sebastian" of Brescia—Altar-pieces at Ancona and in the Vatican—The "Entombment" of the Louvre—The "Madonna di Casa Pesaro"—Place among Titian's works of "St. Peter Martyr."

In the year in which Titian paid his first visit to Ferrara, Ariosto brought out there his first edition of the Orlando Farioso.[35] A greater degree of intimacy between poet and painter has in some quarters been presupposed than probably existed at this stage of Titian's career, when his relation to Alfonso and the Ferrarese Court was far from being as close as it afterwards became. It has accordingly been surmised that in the Worship of Venus and the Bacchanal, painted for Alfonso, we have proof that he yielded to the influence of the romantic poet who infused new life-blood

into the imaginative literature of the Italian Renaissance. In their frank sensuousness, in their fulness of life, in their unforced marriage of humanity to its environment, these very pictures are, however, essentially Pagan and Greek, not by any process of cold and deliberate imitation, but by a similar natural growth from a broad groundwork provided by Nature herself. It was the passionate and unbridled Dosso Dossi who among painters stood in the closest relation to Ariosto, both in his true vein of romanticism and his humorous eccentricity.

[Illustration: The Worship of Venus. Prado Gallery, Madrid. From a Photograph by Braun, Clement, & Cie.]

In the Worship of Venus and the Bacchanal we have left behind already the fresh morning of Titian's genius, represented by the Giorgionesque works already enumerated, and are rapidly approaching its bright noon. Another forward step has been taken, but not without some evaporation of the subtle Giorgionesque perfume exhaled by the more delicate flowers of genius of the first period. The Worship of Venus might be more appropriately named Games of the Loves in Honour of Venus. The subject is taken from the Imagines[36] of Philostratus, a renowned Greek sophist, who, belonging to a late period of the Roman Empire, yet preserved intact the self-conscious grace and charm of the Hellenistic mode of conception. The theme is supplied by a series of paintings, supposed to have been seen by him in a villa near Naples, but by one important group of modern scholars held to be creations of the author's fertile brain. Before a statue of Venus more or less of the Praxitelean type—a more earthly sister of those which have been named the "Townley Venus" and the "Venus d'Arles"—myriads of Loves sport, kissing, fondling, leaping, flying, playing rhythmic games, some of

them shooting arrows at the opposing faction, to which challenge merry answer is made with the flinging of apples. Incomparable is the vigour, the life, the joyousness of the whole, and incomparable must have been the splendour of the colour before the outrages of time (and the cleaner) dimmed it. These delicious pagan amorini are the successors of the angelic putti of an earlier time, whom the Tuscan sculptors of the Quattrocento had already converted into more joyous and more earthly beings than their predecessors had imagined. Such painters of the North, in touch with the South, as Albrecht Duerer, Mabuse, and Jacob Cornelissen van Oostsanen, delighted in scattering through their sacred works these lusty, thick-limbed little urchins, and made them merrier and more mischievous still, with their quaint Northern physiognomy. To say nothing on this occasion of Albani, Poussin, and the Flemish sculptors of the seventeenth century, with Du Quesnoy and Van Opstal at their head, Rubens and Van Dyck derived their chief inspiration in similar subjects from these Loves of Titian.[37]

The sumptuous Bacchanal, for which, we are told, Alfonso gave the commission and supplied the subject in 1518, is a performance of a less delicate charm but a more realistic vigour than its companion. From certain points of analogy with an Ariadne described by Philostratus, it has been very generally assumed that we have here a representation of the daughter of Minos consoled already for the departure of Theseus, whose sail gleams white on the blue sea in the distance. No Dionysus is, however, seen here among the revellers, who, in their orgies, do honour to the god, Ariadne's new lover. The revel in a certain audacious abandon denotes rather the festival from which the protagonists have retired, leaving the scene to the meaner performers. Even a certain agreement in pose between the realistic but lovely figure

of the Bacchante, overcome with the fumes of wine, and the late classic statues then, and until lately, entitled The Sleeping Ariadne, does not lead the writer to believe that we have here the new spouse of Dionysus so lately won back from despair. The undraped figure,[38] both in its attitude and its position in the picture, recalls the half-draped Bacchante, or goddess, in Bellini's Bacchanal at Alnwick. Titian's lovely mortal here may rank as a piece of flesh with Correggio's dazzling Antiope in the Louvre, but not with Giorgione's Venus or Titian's own Antiope, in which a certain feminine dignity spiritualises and shields from scorn beauty unveiled and otherwise defenceless. The climax of the splendid and distinctively Titianesque colour-harmony is the agitated crimson garment of the brown-limbed dancer who, facing his white-robed partner, turns his back to the spectator. This has the strongly marked yellowish lights that we find again in the streaming robe of Bacchus in the National Gallery picture, and yet again in the garment of Nicodemus in the Entombment.

The charming little Tambourine Player, which is No. 181 in the Vienna Gallery, may be placed somewhere near the time of the great works just now described, but rather before than after them.

What that is new remains to be said about the Assunta, or Assumption of the Virgin, which was ordered of Titian as early as 1516, but not shown to the public on the high altar of Santa Maria de' Frari until the 20th of March 1518? To appreciate the greatest of extant Venetian altar-pieces at its true worth it is necessary to recall what had and what had not appeared at the time when it shone undimmed upon the world. Thus Raphael had produced the Stanze, the Cartoons, the Madonnas of Foligno

The Earlier Work of Titian 53

and San Sisto, but not yet the Transfiguration; Michelangelo had six years before uncovered his magnum opus, the Ceiling of the Sixtine Chapel; Andrea del Sarto had some four years earlier completed his beautiful series of frescoes at the Annunziata in Florence. Among painters whom, origin notwithstanding, we must group as Venetians, Palma had in 1515 painted for the altar of the Bombardieri at S. Maria Formosa his famous Santa Barbara; Lorenzo Lotto in the following year had produced his characteristic and, in its charm of fluttering movement, strangely unconventional altar-piece for S. Bartolommeo at Bergamo, the Madonna with Ten Saints. In none of these masterpieces of the full Renaissance, even if they had all been seen by Titian, which was far from being the case, was there any help to be derived in the elaboration of a work which cannot be said to have had any precursor in the art of Venice. There was in existence one altar-piece dealing with the same subject from which Titian might possibly have obtained a hint. This was the Assumption of the Virgin painted by Duerer in 1509 for Jacob Heller, and now only known by Paul Juvenel's copy in the Municipal Gallery at Frankfort. The group of the Apostles gazing up at the Virgin, as she is crowned by the Father and the Son, was at the time of its appearance, in its variety as in its fine balance of line, a magnificent novelty in art. Without exercising a too fanciful ingenuity, it would be possible to find points of contact between this group and the corresponding one in the Assunta. But Titian could not at that time have seen the original of the Heller altar-piece, which was in the Dominican Church at Frankfort, where it remained for a century.[39] He no doubt did see the Assumption in the Marienleben completed in 1510; but then this, though it stands in a definite relation to the Heller altar-piece, is much stiffer and more formal—much less likely to have inspired the master of Cadore. The

Assunta was already in Vasari's time much dimmed, and thus difficult to see in its position on the high altar. Joshua Reynolds, when he visited the Frari in 1752, says that "he saw it near; it was most terribly dark but nobly painted." Now, in the Accademia delle Belle Arti, it shines forth again, not indeed uninjured, but sufficiently restored to its pristine beauty to vindicate its place as one of the greatest productions of Italian art at its highest. The sombre, passionate splendours of the colouring in the lower half, so well adapted to express the supreme agitation of the moment, so grandly contrast with the golden glory of the skies through which the Virgin is triumphantly borne, surrounded by myriads of angels and cherubim, and awaited by the Eternal. This last is a figure the divine serenity of which is the strongest contrast to those terrible representations of the Deity, so relentless in their superhuman majesty, which, in the ceiling of the Sixtine, move through the Infinite and fill the beholder with awe. The over-substantial, the merely mortal figure of the Virgin, in her voluminous red and blue draperies, has often been criticised, and not without some reason. Yet how in this tremendous ensemble, of which her form is, in the more exact sense, the centre of attraction and the climax, to substitute for Titian's conception anything more diaphanous, more ethereal? It is only when we strive to replace the colossal figure in the mind's eye, by a design of another and a more spiritual character, that the difficulty in all its extent is realised.

[Illustration: The Assunta. Accademia delle Belle Arti, Venice.]

Placed as the Assunta now is in the immediate neighbourhood of one of Tintoretto's best-preserved masterpieces, the Miracolo del Schiavo, it undergoes an ordeal from which, in the opinion of many a modern connoisseur and lover of Venetian art, it does

The Earlier Work of Titian

not issue absolutely triumphant. Titian's turbulent rival is more dazzling, more unusual, more overpowering in the lurid splendour of his colour; and he has that unique power of bringing the spectator to a state of mind, akin in its agitation to his own, in which he gladly renounces his power and right to exercise a sane judgment. When he is thoroughly penetrated with his subject, Tintoretto soars perhaps on a stronger pinion and higher above the earth than the elder master. Yet in fulness and variety of life, in unexaggerated dignity, in coherence, in richness and beauty, if not in poetic significance of colour, in grasp of humanity and nature, Titian stands infinitely above his younger competitor. If, unhappily, it were necessary to make a choice between the life-work of the one and the life-work of the other—making the world the poorer by the loss of Titian or Tintoretto—can it be doubted for a moment what the choice would be, even of those who abdicate when they are brought face to face with the mighty genius of the latter?

But to return for a moment to the Assunta. The enlargement of dimensions, the excessive vehemence of movement in the magnificent group of the Apostles is an exaggeration, not a perversion, of truth. It carries the subject into the domain of the heroic, the immeasurable, without depriving it of the great pulsation of life. If in sublime beauty and intellectuality the figures, taken one by one, cannot rank with the finest of those in Raphael's Cartoons, yet they preserve in a higher degree, with dramatic unity and truth, this precious quality of vitality. The expressiveness, the interpretative force of the gesture is the first thought, its rhythmic beauty only the second. This is not always the case with the Cartoons, and the reverse process, everywhere adhered to in the Transfiguration, is what gives to that overrated last work of Sanzio its painfully artificial character. Titian himself in

the St. Sebastian of Brescia, and above all in the much-vaunted masterpiece, The Martyrdom of St. Peter the Dominican, sins in the same direction, but exceptionally only, and, as it were, against his better self.

Little wonder that the Franciscan Fathers were at first uncertain, and only half inclined to be enthusiastic, when they entered into possession of a work hitherto without parallel in Italian or any other art.[40] What is great, and at the same time new, must inevitably suffer opposition at the outset. In this case the public, admitted on the high festival of St. Bernardino's Day in the year 1518 to see the vast panel, showed themselves less timorous, more enthusiastically favourable than the friars had been. Fra Germano, the guardian of Santa Maria de' Frari, and the chief mover in the matter, appears to have offered an apology to the ruffled painter, and the Fathers retained the treasure as against the Imperial Envoy, Adorno, who had seen and admired Titian's wonderful achievement on the day of its ceremonial introduction to the Venetians.

To the year 1519 belongs the Annunciation in the Cathedral of Treviso, the merit of which, in the opinion of the writer, has been greatly overstated. True, the Virgin, kneeling in the foreground as she awaits the divine message, is of unsurpassable suavity and beauty; but the foolish little archangel tumbling into the picture and the grotesquely ill-placed donor go far to mar it. Putting aside for the moment the beautiful and profoundly moving representations of the subject due to the Florentines and the Sienese—both sculptors and painters—south of the Alps, and to the Netherlanders north of them, during the whole of the fifteenth century, the essential triviality of the conception in the Treviso picture makes such a work as

Lorenzo Lotto's pathetic Annunciation at Recanati, for all its excess of agitation, appear dignified by comparison. Titian's own Annunciation, bequeathed to the Scuola di S. Rocco by Amelio Cortona, and still to be seen hung high up on the staircase there, has a design of far greater gravity and appropriateness, and is in many respects the superior of the better known picture.

[Illustration: The Annunciation. Cathedral at Treviso. From a Photograph by Alinari.]

Now again, a few months after the death of Alfonso's Duchess,—the passive, and in later life estimable Lucrezia Borgia, whose character has been wilfully misconceived by the later historians and poets,—our master proceeds by the route of the Po to Ferrara, taking with him, we are told, the finished Bacchanal, already described above. He appears to have again visited the Court in 1520, and yet again in the early part of 1523. On which of these visits he took with him and completed at Ferrara (?) the last of the Bacchanalian series, our Bacchus and Ariadne, is not quite clear. It will not be safe to put the picture too late in the earlier section of Vecelli's work, though, with all its freshness of inspiration and still youthful passion, it shows a further advance on the Worship of Venus and the Bacchanal, and must be deemed to close the great series inaugurated by the Feast of the Gods of Gian Bellino. To the two superb fantasies of Titian already described our National Gallery picture is infinitely superior, and though time has not spared it, any more than it has other great Venetian pictures of the golden time, it is in far better condition than they are. In the Worship of Venus and the Bacchanal the allegiance to Giorgiono has been partly, if not wholly, shaken off; the naivete remains, but not the infinite charm of the earlier Giorgionesque pieces. In the Bacchus

and Ariadne Titian's genius flames up with an intensity of passion such as will hardly again be seen to illuminate it in an imaginative subject of this class. Certainly, with all the beauties of the Venuses, of the Diana and Actaeon, the Diana and Calisto, the Rape of Europa, we descend lower and lower in the quality of the conception as we advance, though the brush more and more reveals its supreme accomplishment, its power to summarise and subordinate. Only in those later pieces, the Venere del Pardo of the Louvre and the Nymph and Shepherd of Vienna, is there a moment of pause, a return to the painted poem of the earlier times, with its exquisite naivete and mitigated sensuousness.

[Illustration: Bacchus and Ariadne. National Gallery. From a Photograph published by the Autotype Company.]

The Bacchus and Ariadne is a Titian which even the Louvre, the Museum of the Prado, and the Vienna Gallery, rich as they are in our master's works, may envy us. The picture is, as it were, under the eye of most readers, and in some shape or form is familiar to all who are interested in Italian art. This time Titian had no second-rate Valerius Flaccus or subtilising Philostratus to guide him, but Catullus himself, whose Epithalamium Pelei et Thetidos he followed with a closeness which did not prevent the pictorial interpretation from being a new creation of the subject, thrilling through with the same noble frenzy that had animated the original. How is it possible to better express the At parte ex alia florens volitabat Iacchus.... Te quaerens, Ariadna, tuoque incensus amore of the Veronese poet than by the youthful, eager movement of the all-conquering god in the canvas of the Venetian? Or to paraphrase with a more penetrating truth those other lines: Horum pars tecta quatiebant cuspide thyrsos; Pars e divolso iactabant membra iuvenco; Pars sese tortis serpentibus

The Earlier Work of Titian 59

incingebant? Ariadne's crown of stars—the Ex Ariadneis aurea temporibus Fixa corona of the poem—shines in Titian's sky with a sublime radiance which corresponds perfectly to the description, so august in its very conciseness, of Catullus. The splendour of the colour in this piece—hardly equalled in its happy audacity, save by the Madonna del Coniglio or Vierge au Lapin of the Louvre,[41] would be a theme delightful to dwell upon, did the prescribed limits of space admit of such an indulgence. Even here, however, where in sympathy with his subject, all aglow with the delights of sense, he has allowed no conventional limitation to restrain his imagination from expressing itself in appropriately daring chromatic harmonies, he cannot be said to have evoked difficulties merely for the sake of conquering them. This is not the sparkling brilliancy of those Veronese transformed into Venetians—Bonifazio Primo and Paolo Caliari; or the gay, stimulating colour-harmony of the Brescian Romanino; or the more violent and self-assertive splendour of Gaudenzio Ferrari; or the mysterious glamour of the poet-painter Dosso Dossi. With Titian the highest degree of poetic fancy, the highest technical accomplishment, are not allowed to obscure the true Venetian dignity and moderation in the use of colour, of which our master may in the full Renaissance be considered the supreme exponent.

The ever-popular picture in the Salon Carre of the Louvre now known as Alfonso I. of Ferrara and Laura Dianti, but in the collection of Charles I. called, with no nearer approach to the truth, Titian's Mistress after the Life, comes in very well at this stage. The exuberant beauty, with the skin of dazzling fairness and the unbound hair of rippling gold, is the last in order of the earthly divinities inspired by Giorgione—the loveliest of all in some respects, the most consummately rendered, but the least

significant, the one nearest still to the realities of life. The chief harmony is here one of dark blue, myrtle green, and white, setting off flesh delicately rosy, the whole enframed in the luminous half-gloom of a background shot through here and there with gleams of light. Vasari described how Titian painted, ottimamente con un braccio sopra un gran pezzo d' artiglieria, the Duke Alfonso, and how he portrayed, too, the Signora Laura, who afterwards became the wife of the duke, che e opera stupenda. It is upon this foundation, and a certain real or fancied resemblance between the cavalier who in the background holds the mirror to his splendid donna and the Alfonso of Ferrara of the Museo del Prado, that the popular designation of this lovely picture is founded, which probably, like so many of its class, represents a fair Venetian courtesan with a lover proud of her fresh, yet full-blown beauty. Now, however, the accomplished biographer of Velazquez, Herr Carl Justi,[42] comes forward with convincing arguments to show that the handsome insouciant personage, with the crisply curling dark hair and beard, in Titian's picture at Madrid cannot possibly be, as has hitherto been almost universally assumed, Alfonso I. of Ferrara, but may very probably be his son, Ercole II. This alone invalidates the favourite designation of the Louvre picture, and renders it highly unlikely that we have here the "stupendous" portrait of the Signora Laura mentioned by Vasari. A comparison of the Madrid portrait with the so-called Giorgio Cornaro of Castle Howard—a famous portrait by Titian of a gentleman holding a hawk, and having a sporting dog as his companion, which was seen at the recent Venetian exhibition of the New Gallery—results in something like certainty that in both is the same personage portrayed. It is not only that the quality and cast of the close curling hair and beard are the same in both portraits, and that the handsome features agree exceedingly well; the sympa-

thetic personage gives in either case the same impression of splendid manhood fully and worthily enjoyed, yet not abused. This means that if the Madrid portrait be taken to present the gracious Ercole II. of Ferrara, then must it be held that also in the Castle Howard picture is Alfonso's son and successor portrayed. In the latter canvas, which bears, according to Crowe and Cavalcaselle, the later signature "Titianus F.," the personage is, it may be, a year or two older. Let it be borne in mind that only on the back of the canvas is, or rather was, to be found the inscription: "Georgius Cornelius, frater Catterinae Cipri et Hierusalem Reginae (sic)," upon the authority of which it bears its present designation.

The altar-piece, The Virgin and Child with Angels, adored by St. Francis, St. Blaise, and a Donor, now in San Domenico, but formerly in San Francesco at Ancona, bears the date 1520 and the signature "Titianus Cadorinus pinsit," this being about the first instance in which the later spelling "Titianus" appears. If as a pictorial achievement it cannot rank with the San Niccolo and the Pesaro altar-pieces, it presents some special points of interest which make it easily distinguishable from these. The conception is marked by a peculiar intensity but rarely to be met with in our master at this stage, and hardly in any other altar-piece of this particular type. It reveals a passionate unrest, an element of the uncurbed, the excessive, which one expects to find rather in Lorenzo Lotto than in Titian, whose dramatic force is generally, even in its most vigorous manifestations, well under control. The design suggests that in some shape or other the painter was acquainted with Raphael's Madonna di Foligno; but it is dramatic and real where the Urbinate's masterpiece was lofty and symbolical. Still Titian's St. Francis, rapt in contemplation, is sublime in steadfastness and intensity of faith; the kneeling

donor is as pathetic in the humility of his adoration as any similar figure in a Quattrocento altar-piece, yet his expressive head is touched with the hand of a master of the full Renaissance. An improved version of the upper portion of the Ancona picture, showing the Madonna and Child with angels in the clouds, appears a little later on in the S. Niccolo altar-piece.

[Illustration: St. Sebastian. Wing of altar-piece in the Church of SS. Nazzaro e Celso, Brescia. From a Photograph by Alinari.]

Coming to the important altar-piece completed in 1522 for the Papal Legate, Averoldo, and originally placed on the high altar in the Church of SS. Nazzaro e Celso at Brescia, we find a marked change of style and sentiment. The St. Sebastian presently to be referred to, constituting the right wing of the altar-piece, was completed before the rest,[43] and excited so great an interest in Venice that Tebaldi, the agent of Duke Alfonso, made an attempt to defeat the Legate and secure the much-talked-of piece for his master. Titian succumbed to an offer of sixty ducats in ready money, thus revealing neither for the first nor the last time the least attractive yet not the least significant side of his character. But at the last moment Alfonso, fearing to make an enemy of the Legate, drew back and left to Titian the discredit without the profit of the transaction. The central compartment of the Brescia altar-piece presents The Resurrection, the upper panels on the left and right show together the Annunciation, the lower left panel depicts the patron saints, Nazarus and Celsus, with the kneeling donor, Averoldo; the lower right panel has the famous St. Sebastian[44] in the foreground, and in the landscape the Angel ministering to St. Roch. The St. Sebastian is neither more nor less than the magnificent academic study of a nude athlete bound to a tree in

such fashion as to bring into violent play at one and the same moment every muscle in his splendidly developed body. There is neither in the figure nor in the beautiful face framed in long falling hair any pretence at suggesting the agony or the ecstasy of martyrdom. A wide gulf indeed separates the mood and the method of this superb bravura piece from the reposeful charm of the Giorgionesque saint in the St. Mark of the Salute, or the healthy realism of the unconcerned St. Sebastian in the S. Niccolo altar-piece. Here, as later on with the St. Peter Martyr, those who admire in Venetian art in general, and in that of Titian in particular, its freedom from mere rhetoric and the deep root that it has in Nature, must protest that in this case moderation and truth are offended by a conception in its very essence artificial. Yet, brought face to face with the work itself, they will put aside the role of critic, and against their better judgment pay homage unreservedly to depth and richness of colour, to irresistible beauty of modelling and painting.[45] Analogies have been drawn between the Medicean Faun and the St. Sebastian, chiefly on account of the strained position of the arms, and the peculiar one of the right leg, both in the statue and the painting; but surely the most obvious and natural resemblance, notwithstanding certain marked variations, is to the figure of Laocoon in the world-famous group of the Vatican. Of this a model had been made by Sansovino for Cardinal Domenico Grimani, and of that model a cast was kept in Titian's workshop, from which he is said to have studied.

[Illustration: DESIGN FOR A HOLY FAMILY. CHATSWORTH. From a photograph by Braun, Clement & Cie.]

[Illustration: La Vierge au Lapin. Louvre. From a Photograph by Neurdein.]

In the Madonna di S. Niccolo, which was painted or rather finished in the succeeding year, 1523, for the little Church of S. Niccolo de' Frari, and is now in the Pinacoteca of the Vatican, the keynote is suavity, unbroken richness and harmony, virtuosity, but not extravagance of technique. The composition must have had much greater unity before the barbarous shaving off, when the picture went to Rome, of the circular top which it had in common with the Assunta, the Ancona, and the Pesaro altarpieces. Technically superior to the second of these great works, it is marked by no such unity of dramatic action and sentiment, by no such passionate identification of the artist with his subject. It is only in passing from one of its beauties to another that its artistic worth can be fully appreciated. Then we admire the rapt expression, not less than the wonderfully painted vestments of the St. Nicholas,[46] the mansuetude of the St. Francis, the Venetian loveliness of the St. Catherine, the palpitating life of the St. Sebastian. The latter is not much more than a handsome, over-plump young gondolier stripped and painted as he was—contemplating, if anything, himself. The figure is just as Vasari describes it, ritratto dal' vivo e senza artificio niuno. The royal saint of Alexandria is a sister in refined elegance of beauty and costume, as in cunning elaboration of coiffure, to the St. Catherine of the Madonna del Coniglio, and the not dissimilar figure in our own Holy Family with St. Catherine at the National Gallery.

The fresco showing St. Christopher wading through the Lagunes with the infant Christ on his shoulder, painted at the foot of a staircase in the Palazzo Ducale leading from the Doge's private apartments to the Senate Hall, belongs either to this year, 1523, or to 1524. It is, so far as we know, Titian's first per-

formance as a frescante since the completion, twelve years previously, of the series at the Scuola del Santo of Padua. As it at present appears, it is broad and solid in execution, rich and brilliant in colour for a fresco, very fairly preserved—deserving, in fact, of a much better reputation as regards technique than Crowe and Cavalcaselle have made for it. The movement is broad and true, the rugged realism of the conception not without its pathos; yet the subject is not lifted high above the commonplace by that penetrating spirit of personal interpretation which can transfigure truth without unduly transforming it. In grandeur of design and decorative character, it is greatly exceeded by the magnificent drawing in black chalk, heightened with white, of the same subject, by Pordenone, in the British Museum. Even the colossal, half-effaced St. Christopher with the Infant Christ, painted by the same master on the wall of a house near the Town Hall at Udine, has a finer swing, a more resistless energy.

[Illustration: St. Christopher with the Infant Christ. Fresco in the Doge's Palace, Venice. From a Photograph by Alinari.]

Where exactly in the life-work of Titian are we to place the Entombment of the Louvre, to which among his sacred works, other than altar-pieces of vast dimensions, the same supreme rank may be accorded which belongs to the Bacchus and Ariadne among purely secular subjects? It was in 1523 that Titian acquired a new and illustrious patron in the person of Federigo Gonzaga II., Marquess of Mantua, son of that most indefatigable of collectors, the Marchioness Isabella d'Este Gonzaga, and nephew of Alfonso of Ferrara. The Entombment being a "Mantua piece,"[47] Crowe and Cavalcaselle have not unnaturally assumed that it was done expressly for the Mantuan

ruler, in which case, as some correspondence published by them goes to show, it must have been painted at, or subsequently to, the latter end of 1523. Judging entirely by the style and technical execution of the canvas itself, the writer feels strongly inclined to place it earlier by some two years or thereabouts—that is to say, to put it back to a period pretty closely following upon that in which the Worship of Venus and the Bacchanal were painted. Mature as Titian's art here is, it reveals, not for the last time, the influence of Giorgione with which its beginnings were saturated. The beautiful head of St. John shows the Giorgionesque type and the Giorgionesque feeling at its highest. The Joseph of Arimathea has the robustness and the passion of the Apostles in the Assunta, the crimson coat of Nicodemus, with its high yellowish lights, is such as we meet with in the Bacchanal. The Magdalen, with her features distorted by grief, resembles—allowing for the necessary differences imposed by the situation—the women making offering to the love-goddess in the Worship of Venus. The figure of the Virgin, on the other hand, enveloped from head to foot in her mantle of cold blue, creates a type which would appear to have much influenced Paolo Veronese and his school. To define the beauty, the supreme concentration of the Entombment, without by dissection killing it, is a task of difficulty. What gives to it that singular power of enchanting the eye and enthralling the spirit, the one in perfect agreement with the other, is perhaps above all its unity, not only of design, but of tone, of informing sentiment. Perfectly satisfying balance and interconnection of the two main groups just stops short of too obvious academic grace—the well-ordered movement, the sweeping rhythm so well serving to accentuate the mournful harmony which envelops the sacred personages, bound together by the bond of the same great sorrow, and from them communicates itself, as it were, to the

beholder. In the colouring, while nothing jars or impairs the concert of the tints taken as a whole, each one stands out, affirming, but not noisily asserting, its own splendour and its own special significance. And yet the yellow of the Magdalen's dress, the deep green of the coat making ruddier the embrowned flesh of sturdy Joseph of Arimathea, the rich shot crimson of Nicodemus's garment, relieved with green and brown, the chilling white of the cloth which supports the wan limbs of Christ, the blue of the Virgin's robe, combine less to produce the impression of great pictorial magnificence than to heighten that of solemn pathos, of portentous tragedy.

Of the frescoes executed by Titian for Doge Andrea Gritti in the Doge's chapel in 1524 no trace now remains. They consisted of a lunette about the altar,[48] with the Virgin and Child between St. Nicholas and the kneeling Doge, figures of the four Evangelists on either side of the altar, and in the lunette above the entrance St. Mark seated on a lion.

[Illustration: The Madonna di Casa Pesaro. Church of S. Maria de' Frari, Venice. From a Photograph by Naya.]

The Madonna di Casa Pesaro, which Titian finished in 1526, after having worked upon it for no less than seven years, is perhaps the masterpiece of the painter of Cadore among the extant altar-pieces of exceptional dimensions, if there be excepted its former companion at the Frari, the Assunta. For ceremonial dignity, for well-ordered pomp and splendour, for the dexterous combination, in a composition of quite sufficient vraisemblance, of divine and sacred with real personages, it has hardly a rival among the extant pictures of its class. And yet, apart from amazement at the pictorial skill shown, at the difficulties over-

come, at the magnificence tempered by due solemnity of the whole, many of us are more languidly interested by this famous canvas than we should care to confess. It would hardly be possible to achieve a more splendid success with the prescribed subject and the material at hand. It is the subject itself that must be deemed to be of the lower and less interesting order. It necessitates the pompous exhibition of the Virgin and Child, of St. Peter and other attendant saints, united by an invisible bond of sympathy and protection, not to a perpetually renewed crowd of unseen worshippers outside the picture, as in Giorgione's Castelfranco Madonna, but merely to the Pesaro family, so proud in their humility as they kneel in adoration, with Jacopo Pesaro, Bishop of Paphos (Baffo), at their head. The natural tie that should unite the sacred personages to the whole outer world, and with it their power to impress, is thus greatly diminished, and we are dangerously near to a condition in which they become merely grand conventional figures in a decorative ensemble of the higher order. To analyse the general scheme or the details of the glorious colour-harmony, which has survived so many drastic renovations and cleanings, is not possible on this occasion, or indeed necessary. The magic of bold and subtle chiaroscuro is obtained by the cloud gently descending along the two gigantic pillars which fill all the upper part of the arched canvas, dark in the main, but illuminated above and below by the light emanating from the divine putti; the boldest feature in the scheme is the striking cinnamon-yellow mantle of St. Peter, worn over a deep blue tunic, the two boldly contrasting with the magnificent dark-red and gold banner of the Borgias crowned with the olive branch Peace.[49] This is an unexpected note of the most stimulating effect, which braces the spectator and saves him from a surfeit of richness. Thus, too, Titian went to work in the Bacchus and Ariadne—giving forth a single clarion note

in the scarlet scarf of the fugitive daughter of Minos. The writer is unable to accept as from the master's own hand the unfinished Virgin and Child which, at the Uffizi, generally passes for the preliminary sketch of the central group in the Pesaro altar-piece. The original sketch in red chalk for the greater part of the composition is in the Albertina at Vienna. The collection of drawings in the Uffizi holds a like original study for the kneeling Baffo.

[Illustration: SKETCH FOR THE MADONNA DI CASA PESARO. ALBERTINA, VIENNA. From a photograph by Braun, Clement & Cie.]

[Illustration: Martyrdom of St. Peter the Dominican. From the engraving by Henri Laurent.]

By common consent through the centuries which have succeeded the placing of Titian's world-renowned Martyrdom of St. Peter the Dominican on the altar of the Brotherhood of St. Peter Martyr, in the vast Church of SS. Giovanni e Paolo, it has been put down as his masterpiece, and as one of the most triumphant achievements of the Renaissance at its maturity. On the 16th of August 1867—one of the blackest of days in the calendar for the lover of Venetian art—the St. Peter Martyr was burnt in the Cappella del Rosario of SS. Giovanni e Paolo, together with one of Giovanni Bellini's finest altar-pieces, the Virgin and Child with Saints and Angels, painted in 1472. Some malign influence had caused the temporary removal to the chapel of these two priceless works during the repair of the first and second altars to the right of the nave. Now the many who never knew the original are compelled to form their estimate of the St. Peter Martyr from the numerous existing copies and prints of all kinds that

remain to give some sort of hint of what the picture was. Any appreciation of the work based on a personal impression may, under the circumstances, appear over-bold. Nothing could well be more hazardous, indeed, than to judge the world's greatest colourist by a translation into black-and-white, or blackened paint, of what he has conceived in the myriad hues of nature. The writer, not having had the good fortune to see the original, has not fallen under the spell of the marvellously suggestive colour-scheme. This Crowe and Cavalcaselle minutely describe, with its prevailing blacks and whites furnished by the robes of the Dominicans, with its sombre, awe-inspiring landscape, in which lurid storm-light is held in check by the divine radiance falling almost perpendicularly from the angels above—with its single startling note of red in the hose of the executioner. It is, therefore, with a certain amount of reluctance that he ventures to own that the composition, notwithstanding its largeness and its tremendous swing, notwithstanding the singular felicity with which it is framed in the overpoweringly grand landscape, has always seemed to him strained and unnatural in its most essential elements. What has been called its Michelangelism has very ingeniously been attributed to the passing influence of Buonarroti, who, fleeing from Florence, passed some months at Venice in 1829, and to that of his adherent Sebastiano Luciani, who, returning to his native city some time after the sack of Rome, had remained there until March in the same year. All the same, is not the exaggeration in the direction of academic loftiness and the rhetoric of passion based rather on the Raphaelism of the later time as it culminated in the Transfiguration? All through the wonderful career of the Urbinate, beginning with the Borghese Entombment, and going on through the Spasimo di Sicilia to the end, there is this tendency to consider the nobility, the academic perfection of a group, a figure, a pose, a ges-

ture in priority to its natural dramatic significance. Much less evident is this tendency in Raphael's greatest works, the Stanze and the Cartoons, in which true dramatic significance and the sovereign beauties of exalted style generally go hand in hand. The Transfiguration itself is, however, the most crying example of the reversal of the natural order in the inception of a great work. In it are many sublime beauties, many figures of unsurpassable majesty if we take them separately. Yet the whole is a failure, or rather two failures, since there are two pictures instead of one in the same frame. Nature, instead of being broadened and developed by art, is here stifled. In the St. Peter Martyr the tremendous figure of the attendant friar fleeing in frenzied terror, with vast draperies all fluttering in the storm-wind, is in attitude and gesture based on nothing in nature. It is a stage-dramatic effect, a carefully studied attitude that we have here, though of the most imposing kind. In the same way the relation of the executioner to the martyred saint, who in the moment of supreme agony appeals to Heaven, is an academic and conventional rather than a true one based on natural truth. Allowing for the point of view exceptionally adopted here by Titian, there is, all the same, extraordinary intensity of a kind in the dramatis personae of the gruesome scene—extraordinary facial expressiveness. An immense effect is undoubtedly made, but not one of the highest sublimity that can come only from truth, which, raising its crest to the heavens, must ever have its feet firmly planted on earth. Still, could one come face to face with this academic marvel as one can still with the St. Sebastian of Brescia, criticism would no doubt be silent, and the magic of the painter par excellence would assert itself. Very curiously it is not any more less contemporary copy—least of all that by Ludovico Cardi da Cigoli now, as a miserable substitute for the original, at SS. Giovanni e Paolo—that gives this impression that Titian

in the original would have prevailed over the recalcitrant critic of his great work. The best notion of the St. Peter Martyr is, so far as the writer is aware, to be derived from an apparently faithful modern copy by Appert, which hangs in the great hall of the Ecole des Beaux-Arts in Paris. Even through this recent repetition the beholder divines beauties, especially in the landscape, which bring him to silence, and lead him, without further carping, to accept Titian as he is. A little more and, criticism notwithstanding, one would find oneself agreeing with Vasari, who, perceiving in the great work a more strict adherence to those narrower rules of art which he had learnt to reverence, than can, as a rule, be discovered in Venetian painting, described it as la piu compiuta, la piu celebrata, e la maggiore e meglio intesa e condotta che altra, la quale in tutta la sua vita Tiziano abbia fatto (sic) ancor mai.

[Illustration: Tobias and the Angel. S. Marciliano, Venice. From a Photograph by Anderson.]

It was after a public competition between Titian, Palma, and Pordenone, instituted by the Brotherhood of St. Peter Martyr, that the great commission was given to the first-named master. Palma had arrived at the end of his too short career, since he died in this same year, 1828. Of Pordenone's design we get a very good notion from the highly-finished drawing of the Martyrdom of St. Peter in the Uffizi, which is either by or, as the writer believes, after the Friulan painter, but is at any rate in conception wholly his. Awkward and abrupt as this may seem in some respects, as compared with Titian's astonishing performance, it represents the subject with a truer, a more tragic pathos. Sublime in its gravity is the group of pitying angels aloft, and infinitely touching the Dominican saint who, in the moment of

violent death, still asserts his faith. Among the drawings which have been deemed to be preliminary sketches for the St. Peter Martyr are: a pen-and-ink sketch in the Louvre showing the assassin chasing the companion of the victim; another, also in the Louvre, in which the murderer gazes at the saint lying dead; yet another at Lille, containing on one sheet thumb-nail sketches of (or from) the attendant friar, the actual massacre, and the angels in mid-air. At the British Museum is the drawing of a soldier attacking the prostrate Dominican, which gives the impression of being an adaptation or variation of that drawing by Titian for the fresco of the Scuola del Santo, A Nobleman murdering his Wife, which is now, as has been pointed out above, at the Ecole des Beaux-Arts of Paris. As to none of the above-mentioned drawings does the writer feel any confidence that they can be ascribed to the hand of Titian himself.[50]

FOOTNOTES

[1] Herr Franz Wickhoff in his now famous article "Giorgione's Bilder zu Roemischen Heldengedichten" (Jahrbuch der Koeniglich Preussischen Kunstsammlungen: Sechzehnter Band, I. Heft) has most ingeniously, and upon what may be deemed solid grounds, renamed this most Giorgionesque of all Giorgiones after an incident in the Thebaid of Statius, Adrastus and Hypsipyle. He gives reasons which may be accepted as convincing for entitling the Three Philosophers, after a familiar incident in Book viii. of the Aeneid, "Aeneas, Evander, and Pallas contemplating the Rock of the Capitol." His not less ingenious explanation of Titian's Sacred and Profane Love will be dealt with a little later on. These identifications are all-important, not only in connection with the works themselves thus renamed, and for the first time satisfactorily explained, but as compelling the students of Giorgione partly to reconsider their view of his art, and, indeed, of the Venetian idyll generally.

[2] For many highly ingenious interpretations of Lotto's portraits and a sustained analysis of his art generally, Mr. Bernard Berenson's Lorenzo Lotto should be consulted. See also M. Emile Michel's article, "Les Portraits de Lorenzo Lotto," in the Gazette des Beaux Arts, 1896, vol. i.

[3] For these and other particulars of the childhood of Titian, see Crowe and Cavalcaselle's elaborate Life and Times of Titian (second edition, 1881), in which are carefully summarised all the general and local authorities on the subject.

[4] Life and Times of Titian, vol. i. p. 29.

[5] Die Galerien zu Muenchen und Dresden, p. 75.

[6] Carlo Ridolfi (better known as a historian of the Venetian school of art than as a Venetian painter of the late time) expressly states that Palma came young to Venice and learnt much from Titan: "C' egli apprese certa dolcezza di colorire che si avvicina alle opere prime dello stesso Tiziano" (Lermolieff: Die Galerien zu Muenchen und Dresden).

[7] Vasari, Le Vite: Giorgione da Castelfranco.

[8] One of these is a description of wedding festivities presided over by the Queen at Asolo, to which came, among many other guests from the capital by the Lagunes, three Venetian gentlemen and three ladies. This gentle company, in a series of conversations, dwell upon, and embroider in many variations, that inexhaustible theme, the love of man for woman. A subject this which, transposed into an atmosphere at once more frankly sensuous and of a higher spirituality, might well have served as the

basis for such a picture as Giorgione's Fete Champetre in the Salon Carre of the Louvre!

[9] Magazine of Art, July 1895.

[10] Life and Times of Titian, vol. i.

[11] Mentioned in one of the inventories of the king's effects, taken after his execution, as Pope Alexander and Seignior Burgeo (Borgia) his son.

[12] La Vie et l'Oeuvre du Titien, 1887.

[13] The inscription on a cartellino at the base of the picture, "Ritratto di uno di Casa Pesaro in Venetia che fu fatto generale di Sta chiesa. Titiano fecit," is unquestionably of much later date than the work itself. The cartellino is entirely out of perspective with the marble floor to which it is supposed to adhere. The part of the background showing the galleys of Pesaro's fleet is so coarsely repainted that the original touch cannot be distinguished. The form "Titiano" is not to be found in any authentic picture by Vecelli. "Ticianus," and much more rarely "Tician," are the forms for the earlier time; "Titianus" is, as a rule, that of the later time. The two forms overlap in certain instances to be presently mentioned.

[14] Kugler's Italian Schools of Painting, re-edited by Sir Henry Layard.

[15] Marcantonio Michiel, who saw this Baptism in the year 1531 in the house of M. Zuanne Ram at S. Stefano in Venice, thus describes it: "La tavola del S. Zuane che battezza Cristo nel

Giordano, che e nel fiume insino alle ginocchia, con el bel paese, ed esso M. Zuanne Ram ritratto sino al cinto, e con la schena contro li spettatori, fu de man de Tiziano" (Notizia d' Opere di Disegno, pubblicata da J. Jacopo Morelli, Ed. Frizzoni, 1884).

[16] This picture having been brought to completion in 1510, and Cima's great altar-piece with the same subject, behind the high-altar in the Church of S. Giovanni in Bragora at Venice, being dated 1494, the inference is irresistible that in this case the head of the school borrowed much and without disguise from the painter who has always been looked upon as one of his close followers. In size, in distribution, in the arrangement and characterisation of the chief groups, the two altar-pieces are so nearly related that the idea of a merely accidental and family resemblance must be dismissed. This type of Christ, then, of a perfect, manly beauty, of a divine meekness tempering majesty, dates back, not to Gian Bellino, but to Cima. The preferred type of the elder master is more passionate, more human. Our own Incredulity of St. Thomas, by Cima, in the National Gallery, shows, in a much more perfunctory fashion, a Christ similarly conceived; and the beautiful Man of Sorrows in the same collection, still nominally ascribed to Giovanni Bellini, if not from Cima's own hand, is at any rate from that of an artist dominated by his influence. When the life-work of the Conegliano master has been more closely studied in connection with that of his contemporaries, it will probably appear that he owes very much less to Bellini than it has been the fashion to assume. The idea of an actual subordinate co-operation with the caposcuola, like that of Bissolo, Rondinelli, Basaiti, and so many others, must be excluded. The earlier and more masculine work of Cima bears a definite relation to that of Bartolommeo Montagna.

[17] The Tobias and the Angel shows some curious points of contact with the large Madonna and Child with St. Agnes and St. John by Titian, in the Louvre—a work which is far from equalling the S. Marciliano picture throughout in quality. The beautiful head of the St. Agnes is but that of the majestic archangel in reverse; the St. John, though much younger than the Tobias, has very much the same type and movement of the head. There is in the Church of S. Caterina at Venice a kind of paraphrase with many variations of the S. Marciliano Titian, assigned by Ridolfi to the great master himself, but by Boschini to Santo Zago (Crowe and Cavalcaselle, vol. ii. p. 432). Here the adapter has ruined Titian's great conception by substituting his own trivial archangel for the superb figure of the original (see also a modern copy of this last piece in the Schack Gallery at Munich). A reproduction of the Titian has for purposes of comparison been placed at the end of the present monograph.

[18] Vasari places the Three Ages after the first visit to Ferrara, that is almost as much too late as he places the Tobias of S. Marciliano too early. He describes its subject as "un pastore ignudo ed una forese chi li porge certi flauti per che suoni."

[19] From an often-cited passage in the Anonimo, describing Giorgione's great Venus now in the Dresden Gallery, in the year 1525, when it was in the house of Jeronimo Marcello at Venice, we learn that it was finished by Titian. The text says: "La tela della Venere nuda, che dorme ni uno paese con Cupidine, fu de mano de Zorzo da Castelfranco; ma lo paese e Cupidine furono finiti da Tiziano." The Cupid, irretrievably damaged, has been altogether removed, but the landscape remains, and it certainly shows a strong family resemblance to those which enframe the figures in the Three Ages, Sacred and Profane Love, and the

"Noli me tangere" of the National Gallery. The same Anonimo in 1530 saw in the house of Gabriel Vendramin at Venice a Dead Christ supported by an Angel, from the hand of Giorgone, which, according to him, had been retouched by Titian. It need hardly be pointed out, at this stage, that the work thus indicated has nothing in common with the coarse and thoroughly second-rate Dead Christ supported by Child-Angels, still to be seen at the Monte di Pieta of Treviso. The engraving of a Dead Christ supported by an Angel, reproduced in M. Lafenestre's Vie et Oeuvre du Titien as having possibly been derived from Giorgione's original, is about as unlike his work or that of Titian as anything in sixteenth-century Italian art could possibly be. In the extravagance of its mannerism it comes much nearer to the late style of Pordenone or to that of his imitators.

[20] Jahrbuch der Preussischen Kunstsammlungen, Heft I. 1895.

[21] See also as to these paintings by Giorgione, the Notizia d' Opere di Disegno, pubblicata da D. Jacopo Morelli, Edizione Frizzoni, 1884.

[22] M. Thausing, Wiener Kunstbriefe, 1884.

[23] Le Meraviglie dell' Arte.

[24] The original drawing by Titian for the subject of this fresco is to be found among those publicly exhibited at the Ecole des Beaux Arts of Paris. It is in error given by Morelli as in the Malcolm Collection, and curiously enough M. Georges Lafenestre repeats this error in his Vie et Oeuvre du Titien. The

drawing differs so essentially from the fresco that it can only be considered as a discarded design for it. It is in the style which Domenico Campagnola, in his Giorgionesque-Titianesque phase, so assiduously imitates. [25] One of the many inaccuracies of Vasari in his biography of Titian is to speak of the St. Mark as "una piccola tavoletta, un S. Marco a sedere in mezzo a certi santi."

[26] In connection with this group of works, all of them belonging to the quite early years of the sixteenth century, there should also be mentioned an extraordinarily interesting and as yet little known Herodias with the head of St. John the Baptist by Sebastiano Luciani, bearing the date 1510. This has recently passed into the rich collection of Mr. George Salting. It shows the painter admirably in his purely Giorgionesque phase, the authentic date bearing witness that it was painted during the lifetime of the Castelfranco master. It groups therefore with the great altar-piece by Sebastiano at S. Giovanni Crisostomo in Venice, with Sir Francis Cook's injured but still lovely Venetian Lady as the Magdalen (the same ruddy blond model), and with the four Giorgionesque Saints in the Church of S. Bartolommeo al Rialto.

[27] Die Galerien zu Muenchen und Dresden.

[28] The Christ of the Pitti Gallery—a bust-figure of the Saviour, relieved against a level far-stretching landscape of the most solemn beauty—must date a good many years after the Cristo della Moneta. In both works the beauty of the hand is especially remarkable. The head of the Pitti Christ in its present state might not conclusively proclaim its origin; but the pathetic and intensely significant landscape is one of Titian's loveliest.

[29] Last seen in public at the Old Masters' Exhibition of the Royal Academy in 1895.

[30] An ingenious suggestion was made, when the Ariosto was last publicly exhibited, that it might be that Portrait of a Gentleman of the House of Barbarigo which, according to Vasari, Titian painted with wonderful skill at the age of eighteen. The broad, masterly technique of the Cobham Hall picture in no way accords, however, with Vasari's description, and marks a degree of accomplishment such as no boy of eighteen, not even Titian, could have attained. And then Vasari's "giubbone di raso inargentato" is not the superbly luminous steel-grey sleeve of this Ariosto, but surely a vest of satin embroidered with silver. The late form of signature, "Titianus F.," on the stone balustrade, which is one of the most Giorgionesque elements of the portrait, is disquieting, and most probably a later addition. It seems likely that the balustrade bore originally only the "V" repeated, which curiously enough occurs also on the similar balustrade of the beautiful Portrait of a young Venetian, by Giorgione, first cited as such by Morelli, and now in the Berlin Gallery, into which it passed from the collection of its discoverer, Dr. J.P. Richter. The signature "Ticianus" occurs, as a rule, on pictures belonging to the latter half of the first period. The works in the earlier half of this first period do not appear to have been signed, the "Titiano F." of the Baffo inscription being admittedly of later date. Thus that the Cristo della Moneta bears the "Ticianus F." on the collar of the Pharisee's shirt is an additional argument in favour of maintaining its date as originally given by Vasari (1514), instead of putting it back to 1508 or thereabouts. Among a good many other paintings with this last signature may be mentioned the Jeune Homme au Gant and

Vierge au Lapin of the Louvre; the Madonna with St. Anthony Abbot of the Uffizi; the Bacchus and Ariadne, the Assunta, the St. Sebastian of Brescia (dated 1522). The Virgin and Child with St. Catherine of the National Gallery, and the Christ with the Pilgrims at Emmaus of the Louvre—neither of them early works—are signed "Tician." The usual signature of the later time is "Titianus F.," among the first works to show it being the Ancona altar-piece and the great Madonna di San Niccolo now in the Pinacoteca of the Vatican. It has been incorrectly stated that the late St. Jerome of the Brera bears the earlier signature, "Ticianus F." This is not the case. The signature is most distinctly "Titianus," though in a somewhat unusual character.

[31] Crowe and Cavalcaselle describe it as a "picture which has not its equal in any period of Giorgione's practice" (History of Painting in North Italy, vol. ii.).

[32] Among other notable portraits belonging to this early period, but to which within it the writer hesitates to assign an exact place, are the so-called Titian's Physician Parma, No. 167 in the Vienna Gallery; the first-rate Portrait of a Young Man (once falsely named Pietro Aretino), No. 1111 in the Alte Pinakothek of Munich; the so-called Alessandro de' Medici in the Hampton Court Gallery. The last-named portrait is a work injured, no doubt, but of extraordinary force and conciseness in the painting, and of no less singular power in the characterisation of a sinister personage whose true name has not yet been discovered.

[33] The fifth Allegory, representing a sphinx or chimaera—now framed with the rest as the centre of an ensemble—is from another and far inferior hand, and, moreover, of different dimensions. The so-called Venus of the Imperial Gallery at

Vienna is, notwithstanding the signature of Bellini and the date (MDXV.), by Bissolo. [34] In Bellini's share in the landscape there is not a little to remind the beholder of the Death of St. Peter Martyr to be found in the Venetian room of the National Gallery, where it is still assigned to the great master himself, though it is beyond reasonable doubt by one of his late pupils or followers.

[35] The enlarged second edition, with the profile portrait of Ariosto by Titian, did not appear until 1532. Among the additions then made were the often-quoted lines in which the poet, enumerating the greatest painters of the time, couples Titian with Leonardo, Andrea Mantegna, Gian Bellino, the two Dossi, Michelangelo, Sebastiano, and Raffael (33rd canto, 2nd ed.).

[36] [Greek: Philostratou Eikonon Erotes.]

[37] Let the reader, among other things of the kind, refer to Rubens's Jardin a Amour, made familiar by so many repetitions and reproductions, and to Van Dyck's Madone aux Perdrix at the Hermitage (see Portfolio: The Collections of Charles I.). Rubens copied, indeed, both the Worship of Venus and the Bacchanal, some time between 1601 and 1608, when the pictures were at Rome. These copies are now in the Museum at Stockholm. The realistic vigour of the Bacchanal proved particularly attractive to the Antwerp master, and he in more than one instance derived inspiration from it. The ultra-realistic Bacchus seated on a Barrel, in the Gallery of the Hermitage at St. Petersburg, contains in the chief figure a pronounced reminiscence of Titian's picture; while the unconventional attitude of the amorino, or Bacchic figure, in attendance on the god, is imi-

tated without alteration from that of the little toper whose action Vasari so explicitly describes.

[38] Vasari's simple description is best: "Una donna nuda che dorme, tanto bella che pare viva, insieme con altre figure."

[39] Moritz Thausing's Albrecht Duerer, Zweiter Band.

[40] Crowe and Cavalcaselle, Life and Times of Titian, vol. i. p. 212.

[41] It appears to the writer that this masterpiece of colour and reposeful charm, with its wonderful gleams of orange, pale turquoise, red, blue, and golden white, with its early signature, "Ticianus F.," should be placed not later than this period. Crowe and Cavalcaselle assign it to the year 1530, and hold it to be the Madonna with St. Catherine, mentioned in a letter of that year written by Giacomo Malatesta to Federigo Gonzaga at Mantua. Should not this last picture be more properly identified with our own superb Madonna and Child with St. John and St. Catherine, No. 635 in the National Gallery, the style of which, notwithstanding the rather Giorgionesque type of the girlish Virgin, shows further advance in a more sweeping breadth and a larger generalisation? The latter, as has already been noted, is signed "Tician."

[42] "Tizian und Alfons von Este," Jahrbuch der Koeniglich Preussischen Kunstsammlungen, Fuenfzehnter Band, II. Heft, 1894.

[43] Crowe and Cavalcaselle, Life and Times of Titian, vol. i.

[44] On the circular base of the column upon which the warrior-saint rests his foot is the signature "Ticianus faciebat MDXXII." This, taken in conjunction with the signature "Titianus" on the Ancona altar-piece painted in 1520, tends to show that the line of demarcation between the two signatures cannot be absolutely fixed.

[45] Lord Wemyss possesses a repetition, probably from Titian's workshop, of the St. Sebastian, slightly smaller than the Brescia original. This cannot have been the picture catalogued by Vanderdoort as among Charles I.'s treasures, since the latter, like the earliest version of the St. Sebastian, preceding the definitive work, showed the saint tied not to a tree, but to a column, and in it the group of St. Roch and the Angel was replaced by the figures of two archers shooting.

[46] Ridolfi, followed in this particular by Crowe and Cavalcaselle, sees in the upturned face of the St. Nicholas a reflection of that of Laocoon in the Vatican group.

[47] It passed with the rest of the Mantua pictures into the collection of Charles I., and was after his execution sold by the Commonwealth to the banker and dealer Jabach for L120. By the latter it was made over to Louis XIV., together with many other masterpieces acquired in the same way.

[48] Crowe and Cavalcaselle, Life and Times of Titian, vol. i.

[49] The victory over the Turks here commemorated was won by Baffo in the service of the Borgia Pope, Alexander VI., some twenty-three years before. This gives a special significance to the position in the picture of St. Peter, who, with the keys at his feet,

stands midway between the Bishop and the Virgin. We have seen Baffo in one of Titian's earliest works (circa 1503) recommended to St. Peter by Alexander VI. just before his departure for this same expedition.

[50] It has been impossible in the first section of these remarks upon the work of the master of Cadore to go into the very important question of the drawings rightly and wrongly ascribed to him. Some attempt will be made in the second section, to be entitled The Later Work of Titian, to deal summarily with this branch of the subject, which has been placed on a more solid basis since Giovanni Morelli disentangled the genuine landscape drawings of the master from those of Domenico Campagnola, and furnished a firm basis for further study.

INDEX

"Alfonso d'Este and Laura Dianti" (Louvre)
Altar-piece at Brescia
"Annunciation, The" (Treviso)
"Annunciation, The" (Venice)
"Aretino, Portrait of" (Florence)
"Ariosto, Portrait of" (Cobham Hall)
"Assumption of the Virgin, The,"
"Bacchanal, A,"
"Bacchus and Ariadne" (National Gallery),
"Baptism of Christ, The" (Rome),
"Battle of Cadore, The"
"Bella, La" (Florence)
"Bishop of Paphos recommended by Alexander VI. to St. Peter, The" (Antwerp)

"Christ at Emmaus"
"Christ bearing the Cross" (Venice)
"Christ between St. Andrew and St. Catherine" (Venice)
"Charles V. at Muehlberg" (Madrid)
"Concert, A" (Florence)
"Cornaro, Portrait of" (Castle Howard)
"Cristo della Moneta, Il" (Dresden)

"Death of St. Peter Martyr, The"
"Diana and Actaeon"
"Diana and Calisto"

"Entombment, The" (Louvre)

"Feast of the Gods, The" (Alnwick Castle)
"Flora" (Florence)
Fresco of St. Christopher in the Doge's Palace
Frescoes in the Scuola del Santo, Padua
Frescoes on the Fondaco de' Tedeschi, Venice

"Herodias"
"Holy Family" (Bridgewater Gallery)
"Holy Family with St. Catherine" (National Gallery)

"Jupiter and Antiope" (Louvre)

"Madonna di Casa Pesaro, The" (Venice)
"Madonna di San Niccolo, The" (Rome)
"Man, Portrait of a" (Munich)
"Man in Black, The" (Louvre)
"Man of Sorrows, The" (Venice)
"Man with the Glove, The" (Louvre)
"Medici, Portrait of Ippolito de'"

"Noli me tangere" (National Gallery)
"Nymph and Shepherd" (Vienna)

"Philip II., Portrait of"
"Pieta" (Milan)

"Rape of Europa, The"

"Sacred and Profane Love" (Rome)
"Sacred Conversation, A" (Chantilly)
"Sacred Conversation, A" (Florence)
"St. Mark enthroned, with four other Saints" (Venice)
"St. Sebastian": see Altar-piece at Brescia

"Tambourine-Player, The" (Vienna)
"Three Ages, The" (Bridgewater Gallery)
"Tobias and the Angel" (Venice)
"Tribute-Money, The": see Cristo della Moneta
"Triumph of Faith, The"

"Vanitas" (Munich)
"Venere del Pardo": see Jupiter and Antiope
"Virgin and Child" (Mr. R.H. Benson)
"Virgin and Child" (Florence)
"Virgin and Child" (St. Petersburg)
"Virgin and Child" (Vienna): see Zingarella, La
"Virgin and Child with Saints" (Captain Holford)
"Virgin and Child with four Saints" (Dresden)
"Virgin and Child with the Infant St. John and St. Anthony Abbot"
 (Florence)
"Virgin and Child with St. Joseph and a Shepherd" (National Gallery)
"Virgin and Child with Saints, Angels, and a Donor" (Ancona)
"Virgin and Child with SS. Stephen, Ambrose, and Maurice" (Louvre)
"Virgin and Child with SS. Ulphus and Bridget" (Madrid)
"Virgin with the Cherries, The" (Vienna)
"Virgin with the Rabbit, The" (Louvre)

"Worship of Venus, The" (Madrid)

"Zingarella, La" (Vienna)

Printed in the United Kingdom
by Lightning Source UK Ltd.
123965UK00001B/279/A